IMAGES
of America

ATHENS AND
LIMESTONE COUNTY

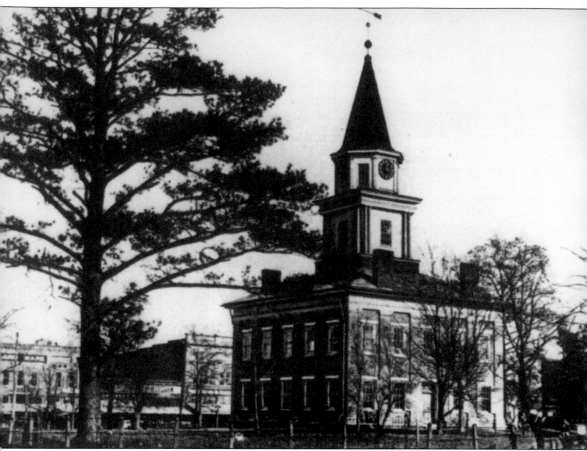

This building was the fourth courthouse in downtown Athens. It was demolished in about 1917 to make room for the current courthouse building. Court business was conducted from storefronts until the new building was completed in 1919. This postcard is dated 1914. (Courtesy of the Athens State University Archives.)

ON THE COVER: Members of Salem United Methodist Church hold a "dinner on the ground" in about 1950. (Courtesy of *Etched in Limestone*.)

IMAGES
of America

ATHENS AND
LIMESTONE COUNTY

Kelly Kazek

ARCADIA
PUBLISHING

Published by Arcadia Publishing
Charleston, South Carolina

Printed in the United States of America

Library of Congress Control Number: 2010921775

For all general information contact Arcadia Publishing at:
Telephone 843-853-2070
Fax 843-853-0044
E-mail sales@arcadiapublishing.com
For customer service and orders:
Toll-Free 1-888-313-2665

Visit us on the Internet at www.arcadiapublishing.com

To the wonderful people of Athens and Limestone County. And to my late parents, Charles and Gayle Caldwell, who loved life here.

CONTENTS

ACKNOWLEDGMENTS

My dear friend Charlotte Fulton's name should be on the cover of this book. Charlotte did much of the research on these pages but, due to other projects, did not participate in this book's publication. She did, however, volunteer her time to help check facts and proof the final draft. I appreciate her sage advice, flawless knowledge of the English language, and her loyal friendship. I don't know how I could have managed without her. Thanks, too, to Penne Laubenthal, another English guru and a former professor at Athens State University, for her assistance with this manuscript. Her expertise and friendship are much appreciated. I also would like to thank Sandra Birdwell and Phillip Reyer at the Limestone County Archives, Sarah Love at the Athens State University Archives, Rita White and Daphne Ellison with Limestone County Emergency Management Agency, and other local historians, many of whom submitted photographs for this book. Thanks to Kim Rynders and Alissa Rose-Clark for their photographs and to Ann Laurence, publisher of the *News Courier*, for her support.

INTRODUCTION
COMMUNITIES OF TRADITION AND FUTURE

Each fall, visitors to Limestone County are greeted by dozens of snow-like fields of cotton, although the acreage dwindles from year to year. The flatness and absence of trees in subdivisions and commercial developments are telltale signs that the acreage once grew cotton. While cotton gins are disappearing from the landscape, churches have held steadfast to their places as spiritual centers of the county's small communities.

Train whistles are still heard at regular intervals throughout the day, although the cars now carry freight and not people. A stop downtown takes visitors back to a time when businesses on the square were the only places to buy goods or get a hot meal. Although strip malls are plentiful throughout the county now, downtown still holds its charm. Local school bands and choirs perform on the courthouse steps, or politicians hold speeches there, just as they have done for decades. It is a place where weekday lunchtime at popular "meat-and-three" diners might find cotton farmers, elected officials, lawyers, clergy, college professors, and NASA contractors discussing civic affairs over fried okra or chicken and dumplings. Limestone County and its seat, the city of Athens, are studies in the ongoing tug-of-war between tradition and progress. But it has been, for the most part, a slow-moving and nonviolent battle. Athens is traditionally a railroad town and cotton town—ranking among the state's largest cotton producers—but since the aerospace boom of the 1960s, it has increasingly entered the orbit of the technology and industry center of Huntsville, home of the U.S. Space and Rocket Center and Redstone Arsenal. In 1934, Athens became the first Alabama city to get its electricity from the Tennessee Valley Authority. TVA began building its first nuclear plant in Limestone County in 1966. Limestone County, named for a creek that runs through it, is bordered by the Tennessee River to the south and the state of Tennessee to the north. The Elk River runs through the western portion of the county. The county is located along major transportation arteries: the Tennessee River, Interstate 65, and U.S. Highway 72. Redstone Arsenal and the Huntsville International Airport are just a half-hour's drive away.

Another boost for the many manufacturers now located in Athens is that the intersection of I-65 and U.S. 72 occurs at nearly the halfway point between Birmingham and Nashville. The natural beauty of the area and man-made attractions combine with its location to make Athens and Limestone County newly discovered tourist destinations. Visitors can choose from trips to Wheeler Wildlife Refuge or along biking, kayaking, and birding trails. They can take drives past well-preserved antebellum homes, the campus of the state's oldest university, or to the quaint and prospering downtown square. It is a place rich in musical history and is giving rise to many artists, musicians, writers, and filmmakers as the arts become a focus of local civic groups. Athens and Limestone County were founded in 1818, the year before Alabama became a state, making Athens one of the oldest cities in Alabama. The county has been home to two Alabama governors, Thomas Bibb and George Houston. A third, Joshua L. Martin, practiced law

in Athens. Athens is the site of one of the most pivotal moments in the Civil War, when Gen. John Turchin was court marshaled for allowing troops to pillage the city after its capture in May 1962. Local lore states that the headmistress of the college (then an all-female academy) saved its buildings from being pillaged by Union troops by producing a letter from President Lincoln. In addition to Athens, with a population of about 26,000 people in 2009, Limestone County has several small, incorporated towns, including Ardmore, Elkmont, Tanner, Lester, and Mooresville, a burg of fewer than 60 souls. The entire town of Mooresville, with its many pre–Civil War homes and buildings, is listed on the National Register of Historic Places. The colorful history of Athens and Limestone County is told with photographs on these pages. They illustrate, better than words, the motto on the masthead of the local newspaper, the *News Courier*: "A Community of Tradition and Future."

One

INFLUENTIAL PEOPLE

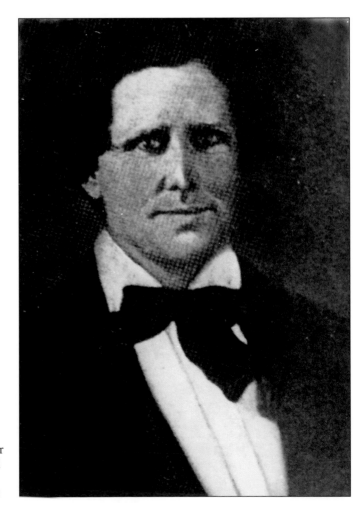

ROBERT BEATY. Along with partner John Carriel, Robert Beaty bought 160 acres of Limestone County land in 1816 and founded the city of Athens, which would be incorporated as seat of Limestone County in 1818. The men donated property for public buildings, such as a jail and school. (Courtesy of the Limestone County Archives.)

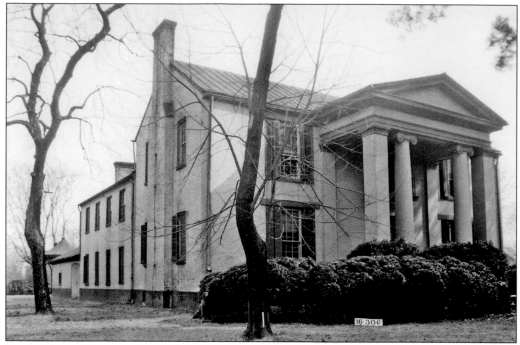

BEATY MASON MANSION. This photograph of the Beaty Mason mansion at 211 South Beaty Street in Athens was taken in 1934, more than a century after it was constructed by Robert Beaty in 1826. The home was deeded to Athens State University in 1958 by an anonymous donor and is now the residence of the university's president. In 2009, the university began raising funds for renovation of the home and made plans to restore the formal gardens and create a reception area. Some of the home's antique furnishings were taken to Limestone Correctional Facility to be restored and refurbished by inmates there. (Courtesy of the Library of Congress, Historic American Building Survey.)

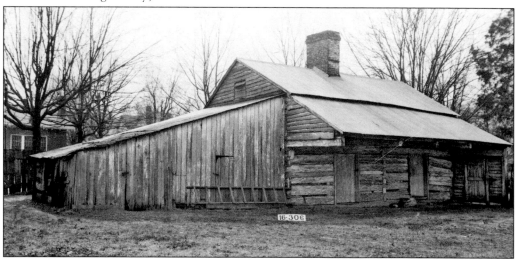

BEATY MASON MANSION SLAVE QUARTERS. The original slave cabin in the side yard of the Beaty Mason home will be restored by Athens State University as materials and funding become available with the goal of possibly creating a guesthouse. (Courtesy of the Library of Congress, Historic American Building Survey.)

Gov. Thomas Bibb. Upon the death of his older brother William Wyatt Bibb—the state's first governor—Thomas Bibb became the second governor of Alabama on July 10, 1820. The state's constitution provided that the president of the senate, Thomas, become acting governor. Thomas was born in Amelia County, Virginia, on April 7, 1783, but he grew up in Elbert County, Georgia. He came to the area that would become Limestone County in 1811. Thomas represented Limestone County at the 1819 Constitutional Convention and then was elected to represent the county in the state senate. He was unanimously chosen president of the senate. Thomas served as governor only until November 1821 and did not seek reelection; however, he returned to the Alabama House of Representatives in 1828 and 1829 and served as director of the Huntsville branch of the Bank of the State of Alabama. (Courtesy of the Limestone County Archives.)

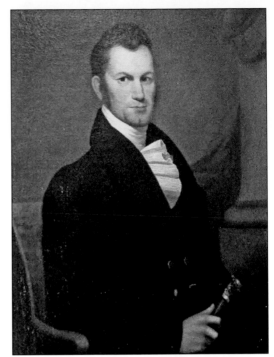

Bibb Home, Belle Mina. Thomas Bibb lived in Limestone County in a plantation home called Belle Mina, built in 1826. Although some say the name is derived from "belle," meaning beautiful, and "mina," meaning coin, others say the home was called Belle Manor, but due to Southern pronunciations, it eventually became Belle Mina. The plantation was built along the Southern Railroad, and there was a station nearby. The surrounding community became known as Belle Mina, and a post office was established in 1878. Thomas was married to Parmelia Thompson, and they had 11 children, three of whom died in infancy. He is buried in Maple Hill Cemetery in Huntsville. (Courtesy of the Frank T. Richardson Jr. collection.)

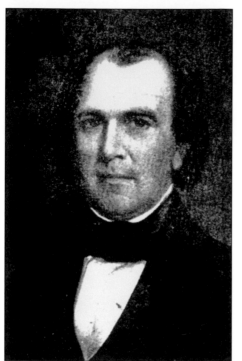

Gov. George Houston. George Smith Houston was born January 17, 1811, in Williamson County, Tennessee, and would become Alabama's 24th governor. Houston came to Lauderdale County, Alabama, earned a law degree, and was elected to the state legislature in 1832. In 1835, he settled in Athens, seat of Limestone County, where he was a lawyer, farmer, and slaveholder. He was elected to the U.S. House of Representatives in 1841 and was reelected to eight more terms. He resigned his position in 1861 when Alabama seceded. In 1874, Democrat Houston was elected governor and served until 1878. He had been elected to the U.S. Senate in 1866, but because Alabama was under Reconstruction, he was not allowed to take his seat. In 1879, he was again elected and served in the Senate from March 4 until his death on December 31, 1879. He is buried in Athens City Cemetery. (Courtesy of the Limestone County Archives.)

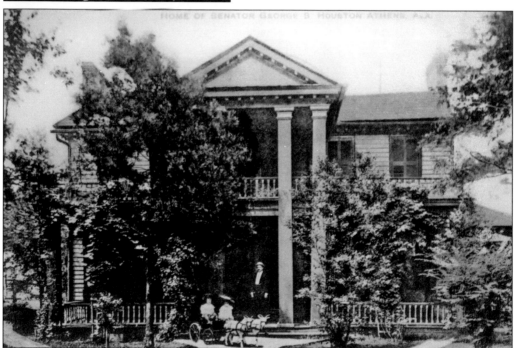

Houston Home. George S. Houston married Mary I. Beatty in 1865, and they had eight children, four of whom survived. Following the death of his first wife, Houston was remarried that year to Ellen Irvine of Florence. They had two children. He lived in this home, built in 1835, on what is now Houston Street in downtown Athens. It is now home to Houston Memorial Library and Museum. (Courtesy of the Limestone County Archives.)

ROBERT DONNELL. The Reverend Robert Donnell was born in 1784, ordained into the ministry in 1813, and died in 1855. Donnell was the chief author of *the Confession of Faith* for the new Cumberland Presbyterian Church, which was officially founded in 1810 according to historians who run the Donnell home as a museum. During his lifetime, Donnell was a Presbyterian circuit rider and helped found churches across northern Alabama and Tennessee. Following the death of his first wife, Ann Eliza Smith, he moved to Mooresville with his second wife, Clara Lindley, then to Athens in 1845. He was respected by the church and local citizens, and a large monument was erected in his memory in Athens City Cemetery. (Artwork photographed by Alissa Rose-Clark; courtesy of the Donnell House and Museum.)

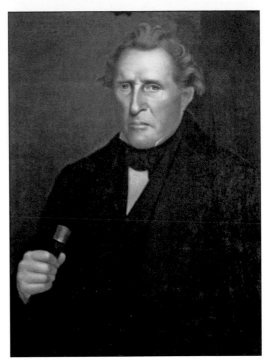

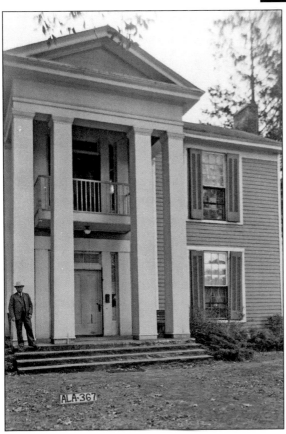

DONNELL HOME. The Reverend Robert Donnell built this home, called Pleasant Hill, on what is now Clinton Street in about 1849. During the "Sack of Athens" in 1862, Union troops camped in the house and on its grounds, and the home was looted and damaged. The home was sold to the Athens City Board of Education in 1879 and then given to the state for use as a public school. Athens Male College held classes in the home until 1889. Other buildings were added to the grounds when the home was in use as a school. The state deeded the home and buildings back to the City of Athens in 1936, and it was used as a residence for teachers and students who attended classes in the surrounding structures. Superintendent of schools Julian Newman and his family lived in the home until his retirement in 1970. It is now surrounded by the more modern buildings that make up Athens Middle School, and the home is open for tours and events. It was placed on the National Register of Historic Places in 1974. (Courtesy of the Library of Congress, Historic American Buildings Survey.)

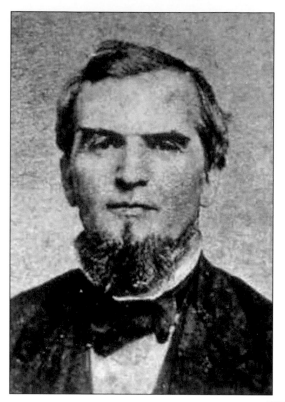

JAMES SLOSS. James Withers Sloss was born in Limestone County, Alabama, on April 7, 1820. He became wealthy as owner of a plantation and a store in Athens. During the Civil War, Sloss served as a colonel. He then became president of the railroad line between Nashville, Tennessee, and Decatur, Alabama, and was instrumental in persuading the Louisville and Nashville Railroad to extend its track between Birmingham and Decatur. Sloss moved to Birmingham, an area he knew contained all the ingredients for making iron—iron ore, coke, and limestone. He was a founding partner in the Pratt Coal and Coke Company, which became one of the largest mining operations in the state. In 1881, he began building a blast furnace to make iron, and City Furnaces opened in 1882. Sloss retired in 1886 and died in May 1890. The furnace site in Birmingham, now called Sloss Furnaces, is now the world's only blast furnace museum and is open for tours. (Courtesy of Sloss Furnaces National Historic Landmark.)

MADAME JANE HAMILTON CHILDS. From 1858 to 1869, Jane Hamilton Childs was president of Athens Female Institute (now Athens State University). During the Civil War, Madame Childs became the subject of legend. Athens was sacked in May 1862 by Union troops who notoriously pillaged and plundered the city, committing atrocities that led to the court martial of Col. John B. Turchin, a pivotal event in the Civil War. Most buildings and homes were burned, looted, or occupied by soldiers. Legend says that when Turchin's soldiers approached the academy, Madame Childs showed them a letter written by Abraham Lincoln, and the college was spared. The veracity of the legend cannot be proven, but history shows that the college was neither occupied nor damaged by troops. (Artwork by Paul Menzal photographed by Kim Rynders; courtesy of the Athens State University Library.)

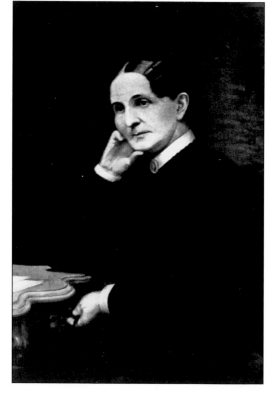

BLIND TOM. Thomas Greene Wiggins was born a slave on May 25, 1849, to Mungo and Charity Wiggins. He was blind and, according to some sources, autistic, but his recall and ability to play tunes on the piano was phenomenal. In 1850, "Blind Tom," which became his stage name, was sold to James Neil Bethune, a lawyer and newspaper editor in Columbus, Georgia. By age four, Tom's musical genius became clear to his owner. He made his concert debut in Atlanta at eight. In 1859, at age 10, he became the first African American performer to play at the White House when he performed for Pres. James Buchanan. Mark Twain often referred to Blind Tom in his writings, saying he was enthralled with his talent. Tom wrote and played his first original composition, *Battle of Manassas*, in 1863. His compositions were recorded in 1999 on the CD *John Davis Plays Blind Tom*. (Courtesy of the Library of Congress.)

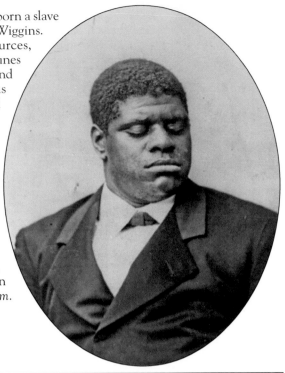

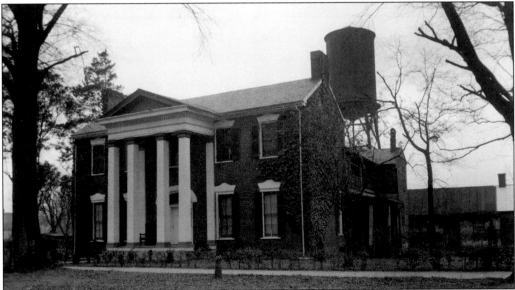

BLIND TOM, VASSER HOME. While it is unclear if Blind Tom ever performed in Athens, he did have a connection with the city. Rebecca Vasser, who grew up in this home on Washington Street, married Col. James Pinkney (sometimes spelled "Pinckney") Howard, and the couple became musical guardians to Tom during his European tour. James Bethune eventually lost custody of Tom to his late son's ex-wife, Eliza Bethune. Blind Tom Wiggins gave his last performance in 1905. He died June 13, 1908, at the age of 59 in Hoboken, New Jersey. The Vining-Vasser-Lovvorn home, built around 1824, still stands. (Courtesy of the Library of Congress, Historic American Buildings Survey.)

THOMAS HUBBARD HOBBS. Much of what historians know about early Limestone County and how it fit into the state and national scheme came from the diaries of Thomas Hubbard Hobbs, which he began in 1840 at age 14 and continued, with interruptions, into 1862. Hobbs (1826–1862) was the only child of Ira and Rebecca Maclin Hobbs. His diaries record interactions with such legendary Limestone County figures as the Reverend Robert Donnell, Nick Davis, Luke Pryor, George Houston, and Madame Jane Hamilton Childs. He organized a volunteer corps of assistant engineers, camping out and traversing North Alabama mountains for more than two months in search of a likely railroad route connecting North and South Alabama. As a member of the Alabama Legislature, he worked with Luke Pryor to get that railroad funded; he also wrote legislation providing that each county have its own superintendent of education. He was a trustee of Wesleyan University and the first male on the board of trustees at Athens Female Institute. *The Journals of Thomas Hubbard Hobbs* was edited and annotated by Faye Acton Axford and published by The University of Alabama Press. (Courtesy of the Limestone County Archives.)

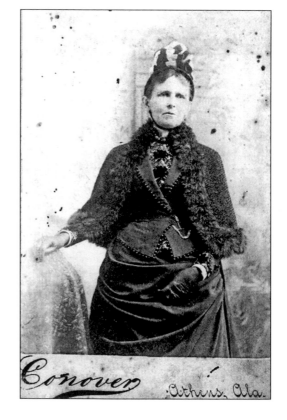

MARY FIELDING. Mary Frances Fielding (1832–1914) was the eldest of 10 children born to William and Sarah Ann Thompson Fielding. She kept a diary during the Civil War when she was a live-in companion to Anna Eliza Hobbs McLin, wife of Dr. Benjamin McLin, through whose Athens household came such historical characters as Gen. Nathan Bedford Forrest and James Garfield. She also was a teacher at Pettusville School. William Eppa Fielding, brother to Mary and Matt, kept a diary while serving with the Confederate army. Excerpts from both diaries can be found in Faye Acton Axford's *To Lochaber Na Mair: Southerners View the Civil War.* (Courtesy of Marvin Wales.)

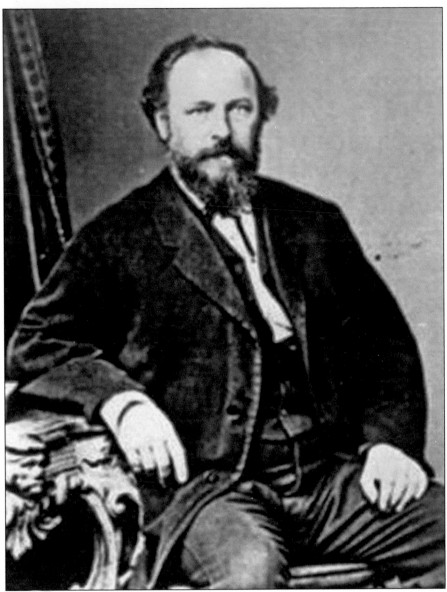

JOHN TURCHIN. John Basil Turchin was born Ivan Vasilovitch Turchinoff in Russia on January 20, 1822. He came to the United States to work for the Illinois Central Railroad in 1856 and was commissioned to serve in the Civil War as a colonel of the 19th Illinois Volunteers in June 1861. He was in charge of the Union troops that invaded Athens on May 2, 1862, looting and torching the city and committing atrocities on its citizens. These actions changed the tone of the war, which had, until that point, been fought as a "gentlemen's war." Maj. Gen. Don Carlos Buell, known for protecting the rights and properties of Southerners, ordered a court martial for Turchin. The trial was held in the Limestone County Courthouse in July 1862. It was presided over by Brig. Gen. James A. Garfield, who later became president, and made headlines in newspapers nationwide. Turchin was convicted for crimes committed during the Sack of Athens but did not serve time. During the trial, President Lincoln promoted Turchin to brigadier general, which meant Turchin had not been judged by a jury of his peers; only one trial officer, Garfield, had the rank of general. This action nullified the conviction. (Courtesy of the Limestone County Archives.)

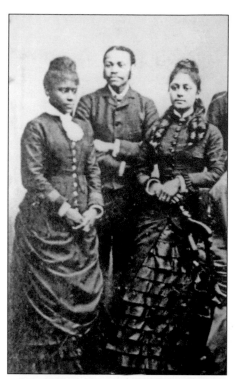

PATTI MALONE. Born a slave, Patti J. Malone (left) became a world-renowned mezzo-soprano with the Fisk Jubilee Singers. She was born around 1858 at Cedars Plantation in Athens. After the Civil War, Malone enrolled in Trinity School, founded by the American Missionary Association for the children of former slaves. After finishing her studies at Trinity, Malone enrolled at Fisk University in Nashville, Tennessee, a college that also had been established by the American Missionary Association. At the behest of Mary Wells, the headmistress of Trinity School and former chaperone of the Fisk Jubilee Singers, Malone joined the singing group on its tour of Germany in 1877, where the singers held a command performance for German emperor Wilhelm the First. Malone performed with the group through Europe, Australia, and New Zealand. She died in Omaha, Nebraska, on January 20, 1897. (Courtesy of the Limestone County Archives.)

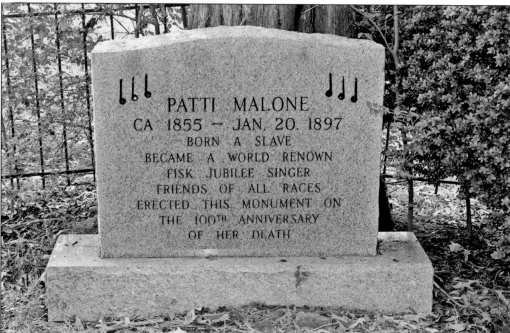

MALONE GRAVE SITE. After her death in 1897, the body of Patti Malone was returned to her native Athens for burial in Hine and Hobbs Cemetery. A monument was erected in 1997 that reads, "Patti Malone Ca 1855–Jan. 20, 1897. Born a slave; became a world renown [*sic*] Fisk Jubilee Singer. Friends of all races erected this monument on the 100th anniversary of her death." (Author's collection.)

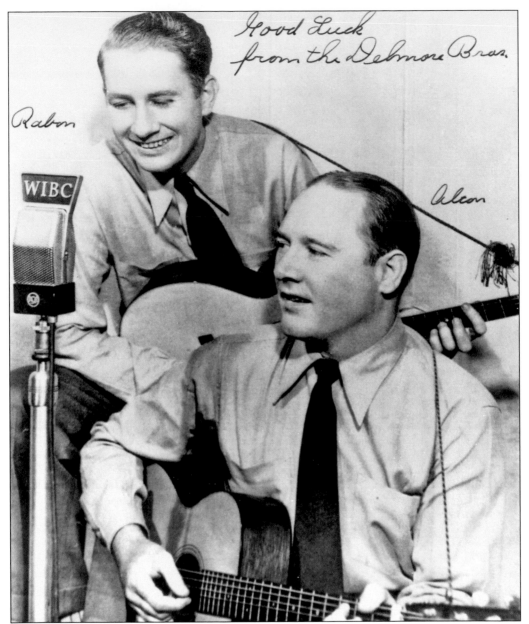

Good Luck
from the Delmore Bros.

Rabon

Alton

WIBC

ALTON AND RABON DELMORE. Alton Delmore (December 25, 1908–June 8, 1964) and Rabon Delmore (December 3, 1916–December 4, 1952) were born in Elkmont in Limestone County to tenant farmers. Their mother, Mollie Delmore, wrote and sang gospel songs for a local church, and the boys grew up listening to gospel and Appalachian folk music. They soon began their own singing duo, The Delmore Brothers, becoming stars of the Grand Ole Opry in the 1930s. A festival called Delmore Days held in Limestone County each summer celebrates the duo's contributions to country music. Singer Bob Dylan was quoted in the *Chicago Tribune* in 1985 on the brothers' impact: "The Delmore Brothers, God, I really loved them! I think they've influenced every harmony I've ever tried to sing." (Courtesy of the *News Courier*.)

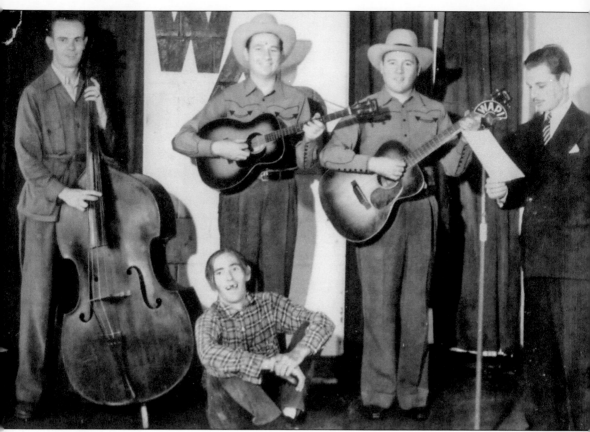

THE DELMORE BROTHERS. In 1971, the Delmore Brothers, shown above during a radio program, were inducted into the Nashville Songwriters Hall of Fame, followed by the Alabama Country Music Hall of Fame in 1987, the Alabama Music Hall of Fame in 1989, and the Country Music Hall of Fame in 2001. Some of the brothers' popular tunes included "Brown's Ferry Blues," named for Limestone County's Brown's Ferry, which once transported people across the Tennessee River; "Gonna Lay Down My Old Guitar;" and "Fifteen Miles from Birmingham." (Courtesy of the Limestone County Archives.)

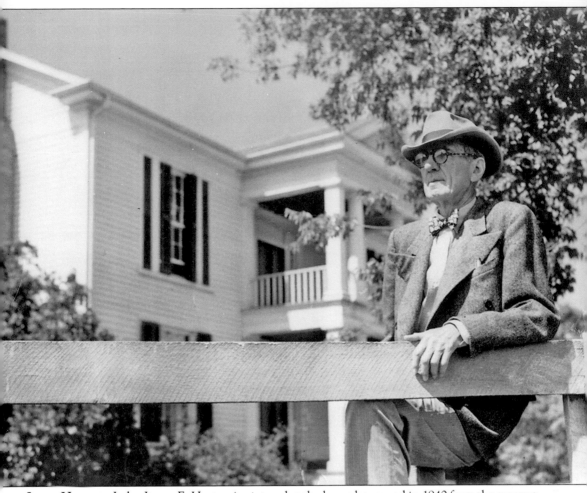

JAMES HORTON. Judge James E. Horton is pictured at the home he moved in 1940 from the current site of Athens City Hall on Hobbs Street to his farm in Greenbrier. This photograph was taken after the house was moved, piece by piece, to Greenbrier. Horton gained international attention in 1933 when, as presiding judge of the 8th Judicial Circuit, he overturned the conviction of Haywood Patterson, ordering a new trial for one of the nine Scottsboro boys charged with raping two white women aboard a train in Scottsboro. One of the accusers later recanted her testimony. In a 1975 article in the *New York Times*, civil rights attorney Elias M. Schwarzbart says of what Horton's courageous decision set into motion: "In retrospect, the Scottsboro Case may be seen as a lightning flash that signaled the reawakening of the civil rights movement after the long sleep since Reconstruction—a movement that was to break into full flame in the civil rights struggles of the 1960s and culminate in the historic Civil Rights Act of 1964 and the Voting Rights Acts of 1965 and 1970." Horton lost his bid for reelection in 1934 after carrying Limestone and Lawrence counties but losing in Cullman and Morgan. (Courtesy of Ed Horton.)

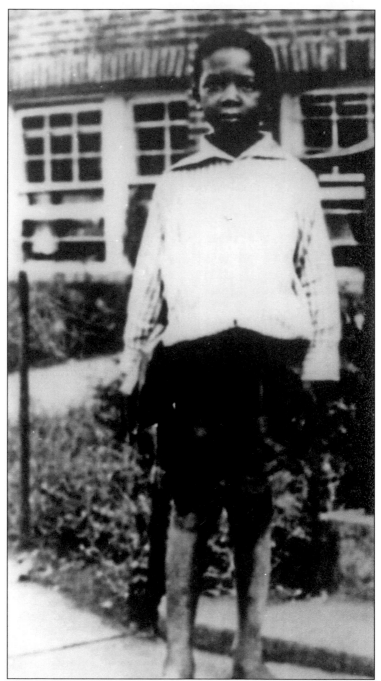

C. Eric Lincoln. Dr. Charles Eric Lincoln was born in Athens on June 23, 1924. Shown here as a child, he became a professor emeritus of religion and culture at Duke University and author of more than 20 books, including *The Black Church in the African-American Experience* and the novel *The Avenue, Clayton City*, which won the Lillian Smith Award for Best Southern Fiction. His book *The Black Muslims in America* lent prominence to Muslim leader Malcolm X. The two men became friends, and Lincoln is mentioned in *The Autobiography of Malcolm X*. (Courtesy of the Limestone County Archives.)

Two

IMPORTANT PLACES

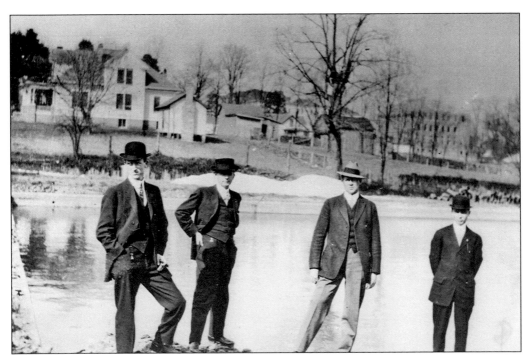

BIG SPRING. Of Limestone County's three springs used as water sources for first settlers, this one, called Big Spring, fed water to Athens residents. Ewell Smith, grandfather of the man who submitted this image, is on the far right, and the other men are unidentified in this photograph taken between 1930 and 1938. In the background is the old Hightower house where Lawler's Barbecue now stands. Athens College is also visible. (Courtesy of Ewell Smith.)

L. & N. R. R. Station, Athens, Ala.

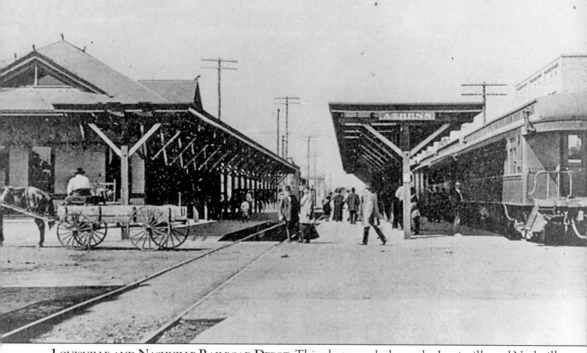

LOUISVILLE AND NASHVILLE RAILROAD DEPOT. This photograph shows the Louisville and Nashville Railroad depot in Athens in the early 1900s. (Courtesy of Richard Martin.)

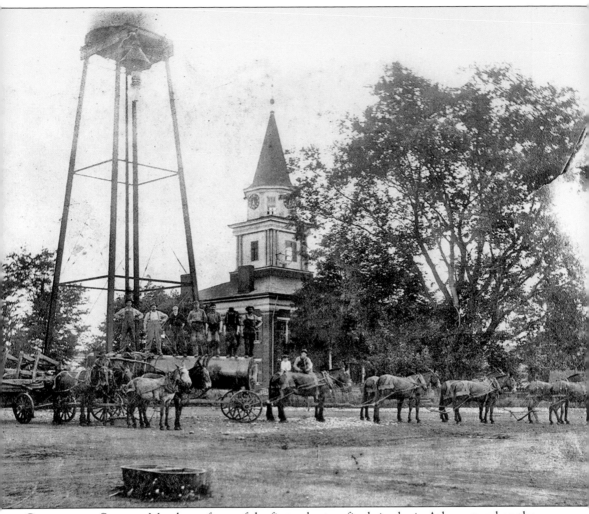

COURTHOUSE SQUARE. Members of one of the first volunteer fire brigades in Athens stand on the Limestone County Courthouse Square with firefighting equipment. At left, a four-mule team carries the hose and pumps, and at right, an eight-mule team pulls the portable tank. In the background is a water tower erected for fire protection sometime after 1864 when the third courthouse was destroyed by fire. The fourth courthouse was demolished in 1916 for the erection of the present one. In the background, a bell hangs from the water tower, ready to summon firefighters. The object in the foreground is a two-horse watering trough. (Courtesy of Travis Raney.)

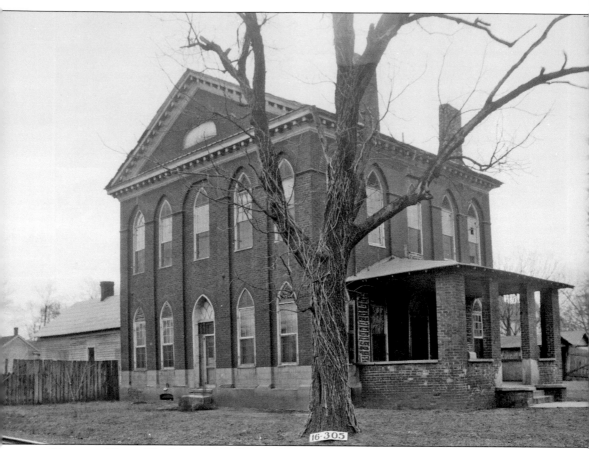

MASONIC HALL. The Masonic Hall in Athens was built in 1826, giving a permanent meeting place to members who previously met in a tavern on the downtown square. The large building was offered to the community for many uses: school was held on the first floor until the 1830s, a church congregation met there, a millinery shop opened in a portion of the building after the Civil War, and then it was used as a private school beginning in 1909. It eventually fell into ruin and was demolished in the 1920s. (Courtesy of the Library of Congress, Historic American Buildings Survey.)

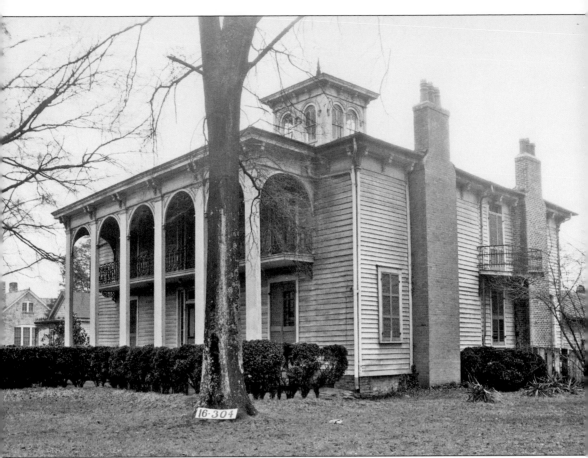

LUKE PRYOR HOUSE. The home known as the Murrah-Maples-Pryor house on North Jefferson Street was built around 1838. It became the home of Luke and Isabella Pryor after their marriage in 1854. While a member of the Alabama Legislature, Luke worked to get the Tennessee and Alabama Central Railroad built. The first locomotive to run on this line was called the *Luke Pryor*, according to *The Lure and Lore of Limestone County* by Faye Axford. Pryor was a law partner of George Houston in Athens. Houston was elected governor in 1874, and Pryor became a U.S. Senator in 1879. The home is referred to by the Historic American Buildings Survey as the Frances Snow Pryor house because Frances Snow, one of the Pryors' daughters, lived in the home at the time of the survey. She died in 1935. The small building beside the home with the wrought iron decorations may have been used as Pryor's law office. The home is a private residence today. (Courtesy of the Library of Congress, Historic American Buildings Survey.)

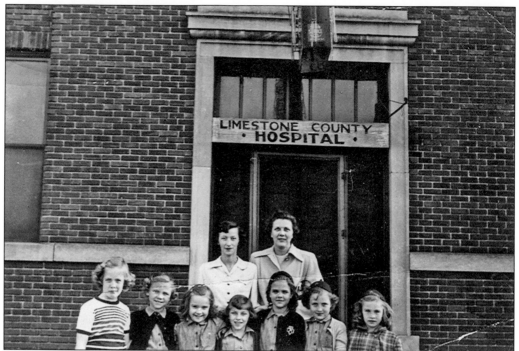

LIMESTONE COUNTY HOSPITAL. In this image, a group of Brownie Scouts stand in front of Limestone County Hospital, which was built and operated by Dr. J. O. Belue. It was located on Market Street just off the courthouse square. (Courtesy of Brenda Daniel and Ewell Smith.)

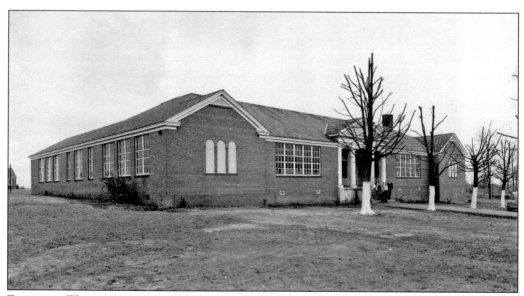

ELKMONT. The tiny community of Elkmont was home to the first public school in Limestone County. According to the late historian Faye Axford, a school began in the community as early as 1873. Initially called Limestone County High School, the name was changed to Elkmont High School as other schools began opening around the county. This building was constructed in 1949 after the previous school was damaged by a tornado. Elkmont is now an incorporated town of about 500 residents. (Courtesy of the Limestone County Archives.)

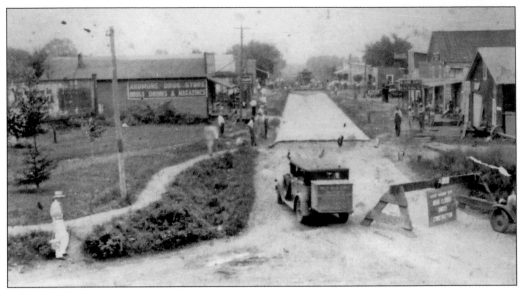

AUSTIN-ARDMORE. The town of Ardmore in northeastern Limestone County, initially called Austin after founder Alex Austin, took the name of the Louisville and Nashville (L&N) Railroad depot at the site sometime after 1910. This early photograph shows Ardmore's Main Street. (Courtesy of the Limestone County Archives.)

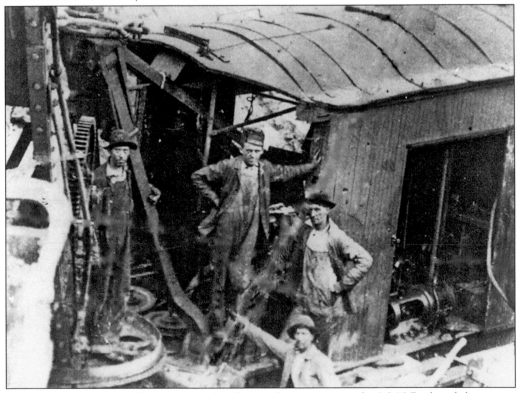

ARDMORE. Until a building was completed at Ardmore in 1916, the L&N Railroad depot was housed in a boxcar on the side rails. This photograph was likely taken between 1910 and 1916. L&N closed the passenger and freight depot in 1965. (Courtesy of the Ardmore Public Library.)

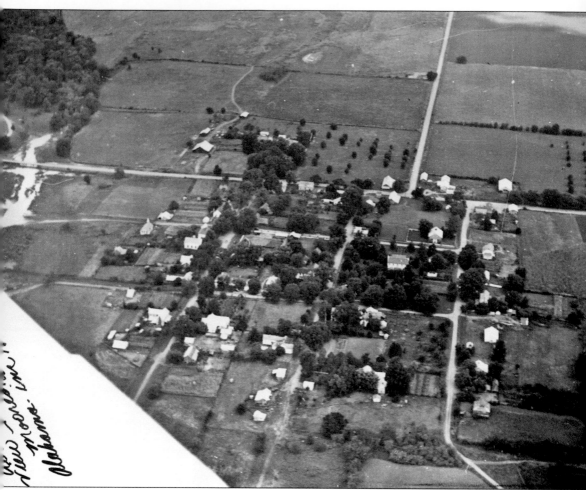

MOORESVILLE. This aerial view of the historic town of Mooresville in southern Limestone County was taken in the 1930s or 1940s by resident Frank T. Richardson Jr. as his wife piloted the plane. The entire town of Mooresville, which in 2009 had 53 residents, is listed on the National Register of Historic Places. Mooresville's history began in 1805 when the first settlers arrived in the area and set up homesteads on lands occupied by the Chickasaw Indians, who later ceded the land to the federal government. Public sale of land began in 1816. The 62 residents of Mooresville petitioned the Alabama Territorial Legislature for incorporation in 1818, the same year Limestone County was formed and one year before Alabama became a state. (Courtesy of the Frank T. Richardson Jr. collection.)

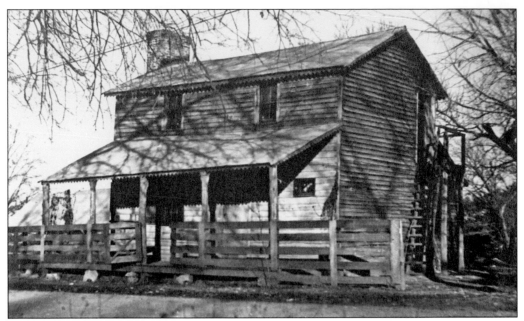

MOORESVILLE STAGECOACH INN AND TAVERN. This tavern in Mooresville was built around 1821. It stills stands on High Street and is now a tourist attraction. This photograph was taken in the 1930s. The Stagecoach Inn acted as the town's post office, until a separate facility was erected around 1840. The original post office was located on the right side of the building, and mail passed to recipients through a small window. A road was constructed between the two towns and mail was carried by horse and rider. The Stagecoach Inn and Tavern was listed on Tanner's Post Map of 1825 with supper priced at "2 bits." (Courtesy of the Frank T. Richardson Jr. collection.)

TAVERN INTERIOR. The Stagecoach Inn and Tavern in Mooresville was built by Griffin Lampkin and has had several owners, including David E. Putney, who bought it in 1825 for $1,500. When the building was an inn, the first floor was used as a common room and included this fireplace, pictured in the 1930s prior to a restoration. The building had an exterior stairway leading to two sleeping rooms. Now owned by the Town of Mooresville, the tavern was restored in the mid-1990s. (Courtesy of the Library of Congress, Historic American Buildings Survey.)

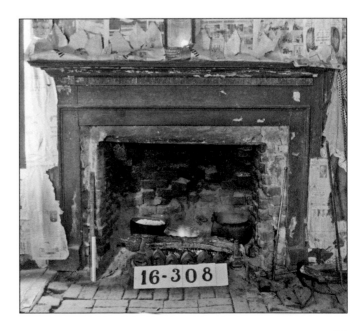

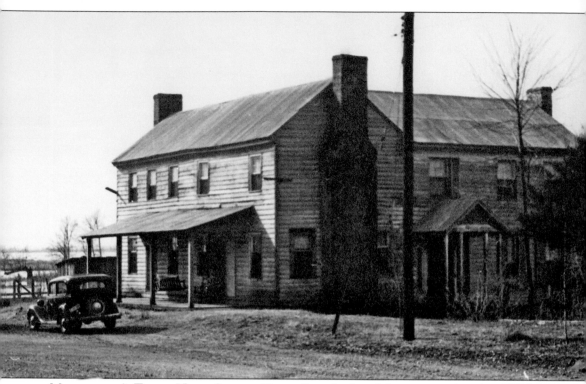

MOORESVILLE'S THACH-HURN-SHERILL HOME. Pres. Andrew Johnson stayed in this 1850 home, now known as the Thach-Hurn-Sherill home in Mooresville, while he was studying to be a tailor. A notation on the photograph, taken in the 1930s, states that Johnson studied his craft inside this home, but a local historian said it is more likely he boarded in the home and studied his craft in another building in the town. (Courtesy of the Frank T. Richardson Jr. collection.)

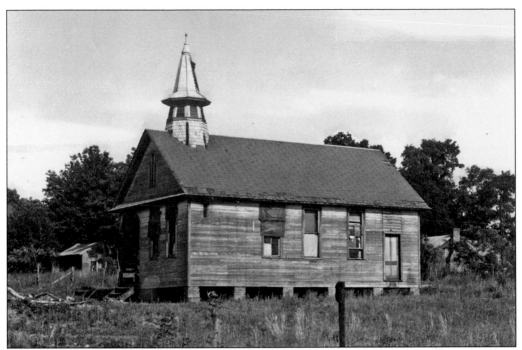

MOORESVILLE SCHOOLHOUSE. This wooden building constructed in 1865 was the schoolhouse in Mooresville and was later used as the county's first Masonic Lodge. The photographer who took this image in the early 1930s, Frank T. Richardson Jr., said he and his sister, known as "PeePie," attended the school. It was torn down in 1932. (Courtesy of the Frank T. Richardson Jr. collection.)

STATE'S LONGEST-OPERATING POST OFFICE. Mooresville Post Office has been operating from the same building for 150 years, making it the oldest operational post office in the state of Alabama. The boxes, numbered 1–48, and some furnishings are older than the building. They were transferred from the Stagecoach Inn and Tavern that once housed the town's postal service. This photograph was taken in the 1960s, and the building looks much the same today. (Courtesy of the Frank T. Richardson Jr. collection.)

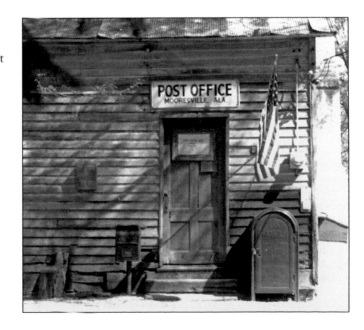

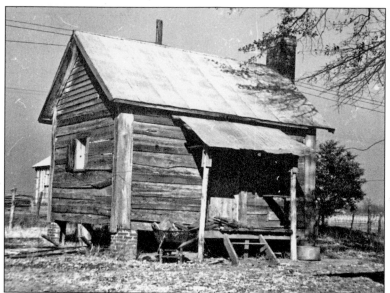

MOORESVILLE TENANT FARMER HOME. This log house, built about 1850, was a tenant farmer's cabin in Mooresville. A notation on the photograph, taken in the 1930s, states it also was once used as a school. (Courtesy of the Frank T. Richardson Jr. collection.)

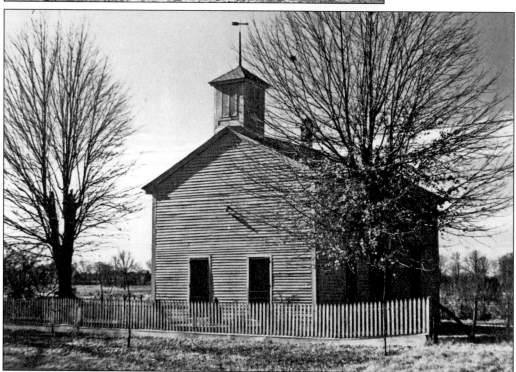

MOORESVILLE CHURCH OF CHRIST. Located on Market Street, Mooresville's Church of Christ was originally built in 1854 as the Disciples of Christ meetinghouse. It still stands, now painted white, and is a tourist attraction. A vestibule and the rear wing were added around 1937 after this photograph was taken. When he was a general in 1863, James A. Garfield, who would later become the nation's 20th president, preached there while he was encamped at nearby Bibb's Spring with the 42nd Regiment of the Ohio Volunteers. The Bible he is said to have used during the service was kept at the church until a few years ago when it was removed to be restored and preserved. (Courtesy of the Frank T. Richardson Jr. collection.)

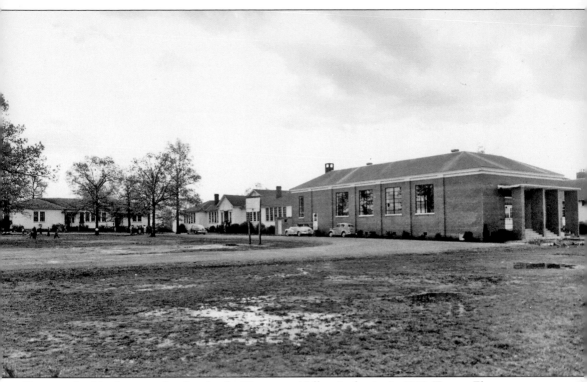

TANNER. In this photograph taken by the Tennessee Valley Authority in 1949, Tanner Elementary School is in the background to the left, the junior and senior high are center, and the gym is in the foreground. The Tanner Community built up in the early 1900s in southeastern Limestone County around the Louisville and Nashville Railroad line that ran from Decatur, Alabama, to Nashville. (Courtesy of the Tennessee Valley Authority.)

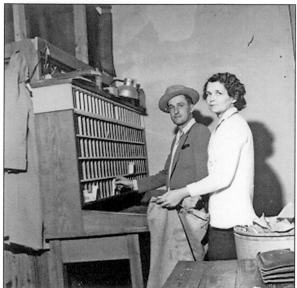

LESTER POST OFFICE. The tiny community of Lester in western Limestone County operated its post office in Lester Jackson's store. Rural carrier Walton Jackson and Lester's first postmaster, Margaret Jackson, are pictured inside the post office in this 1958 photograph. (Courtesy of Dan Jackson.)

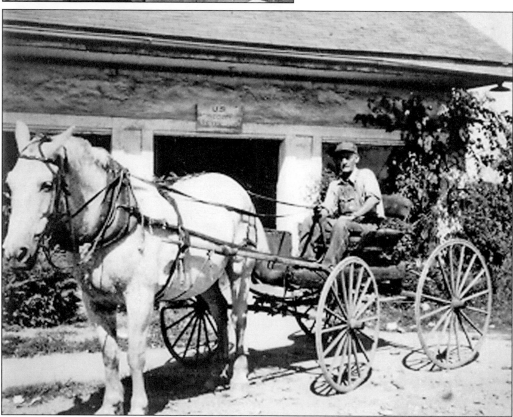

LESTER. Lewis Hall, star route carrier, is pictured outside the post office at Lester. Hall used his own pickup truck to transport mail each morning from the Athens Post Office to the Elkmont and Lester Post Offices. Later in the day, he would transport mail back to Athens that had been collected on the Elkmont and Lester routes. Rather than driving back home in between jobs, Hall stayed in Lester and worked a cotton crop during the day. (Courtesy of Dan Jackson.)

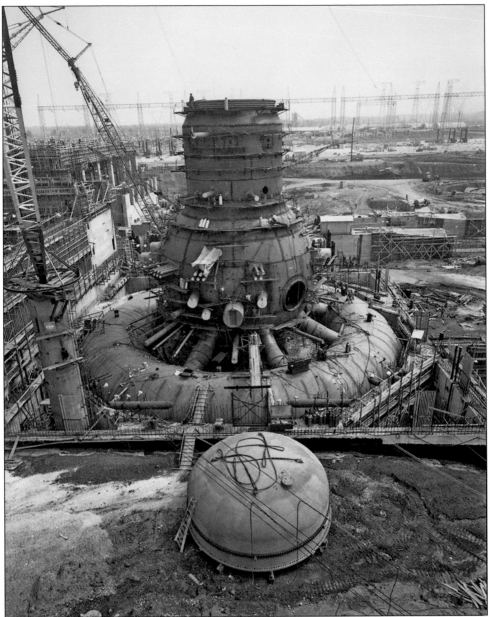

BROWNS FERRY NUCLEAR PLANT. The Tennessee Valley Authority's first nuclear plant was built near the site of Brown's Ferry, which was used as a method of transportation across the Tennessee River until the mid-20th century. Construction on Browns Ferry Nuclear Plant was begun in 1966. This photograph shows the Unit 1 reactor under construction. Upon completion, Browns Ferry was the largest nuclear plant in the world. The plant has three General Electric boiling water reactors. Unit 1 began commercial operation on August 1, 1974. On March 22, 1975, a worker using a candle to check for air leaks started a fire and led to what some historians describe as the most serious nuclear accident in U.S. history, with the exception of the Three Mile Island incident. The fire began among control wires and caused a temporary threat to the reactor. Following the incident, the Nuclear Regulatory Commission instituted new safety regulations. The plant continues to operate today. (Courtesy of the Tennessee Valley Authority.)

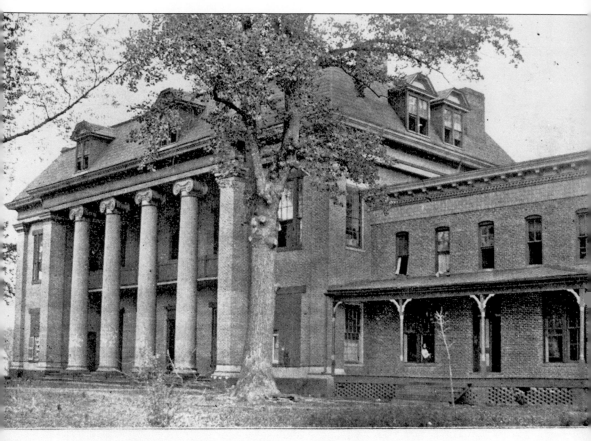

ATHENS FEMALE COLLEGE, ATHENS, ALA.

ATHENS STATE UNIVERSITY FOUNDERS HALL. Athens State University was founded in 1822 as an ecumenical female academy. In 1842, the Tennessee Conference of the Methodist Church took over the school, and it was renamed Athens Female Institute. The building that became known as Founders Hall, above, was constructed in 1842. This photograph was taken around 1880. The columns were the work of a master mason and a slave and are considered to be architecturally perfect. They were given the names Matthew, Mark, Luke, and John by students. Rumor also says that, during building, a jug of whiskey was left inside one of the columns. The structure once had faculty apartments and quarters for the president's family but now serves as the university's main building, with offices, a parlor, and the chapel. In 1870, Athens Female Institute came under the jurisdiction of the newly formed North Alabama Conference of the Methodist Church, then it was ceded to the state in 1975 when it became Athens State College. It received the university designation in 1998. (Courtesy of the Athens State University Archives.)

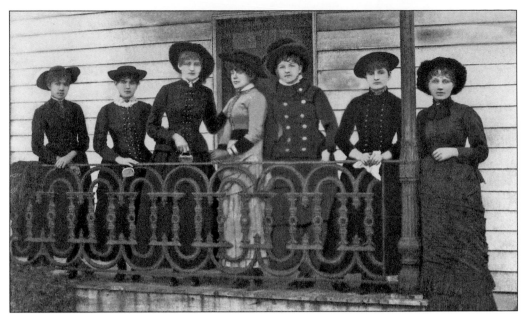

ATHENS STATE UNIVERSITY GRADUATES. Shown in this photograph of the 1833 graduating class of Athens Female Academy are, from left to right, Ada Westmoreland, Mattie Thatch, Rowe Sanders, Hattie Pryor, Fawn Comen, Sallie Mott Malone, and Octavia Wilson. Descendants Mattie Thatch Rose and Sue Montgomery donated the image to the archives of Athens State University. (Courtesy of the Athens State University Archives.)

ATHENS STATE UNIVERSITY SORORITY LIFE. This photograph of members of Phi Sigma sorority at Athens Female Academy appeared in the 1923 yearbook, which was called *Maid of Athens*. The academy later became a state college and is now known as Athens State University. (Courtesy of the Athens State University Archives.)

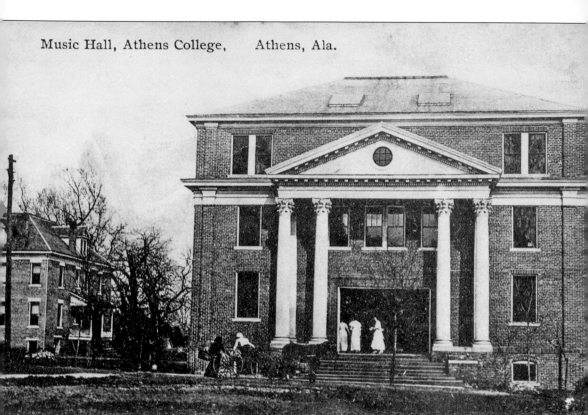

Music Hall, Athens College, Athens, Ala.

ATHENS STATE UNIVERSITY MCCANDLESS HALL. McCandless Hall was built on the campus of what was then Athens Female College in 1912 after president Mary Norman Moore told board members the school needed an auditorium. When the project was deemed too costly, Moore submitted her resignation, which made the board quickly reconsider. It is named for Kate Leslie McCandless, a concert pianist who directed the music department at the college in the early 1900s. It is still in use as an auditorium for the college and the community. (Courtesy of the Athens State University Archives.)

STATE SECONDARY AGRICULTURE SCHOOL. The State Secondary Agriculture School class of 1923 is shown in this photograph. The school opened in 1889 after the City of Athens was the highest bidder for an agricultural school and experiment station. It was an all-boys school until 1894. It merged with Athens City High in 1936 to become Athens High School. (Courtesy of the Limestone County Archives.)

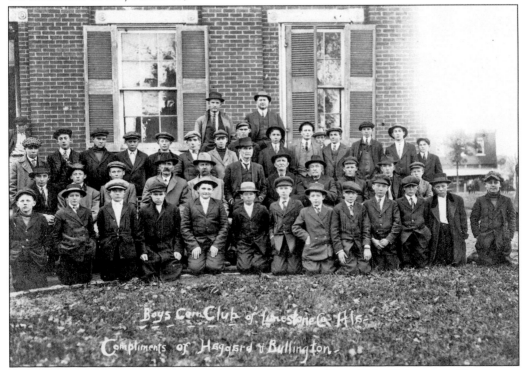

AGRICULTURE SCHOOL CORN CLUB. Members of the Boys Corn Club of Limestone County are shown around 1917 at the 8th District Agricultural School. The Corn Club was a project of 4-H Clubs, and girls could join the Tomato Club. The students studied soil and growing methods. (Courtesy of Evelyn Zehner Johnson.)

43

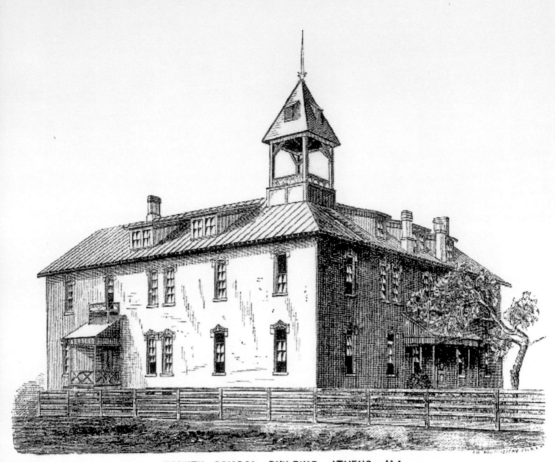

TRINITY SCHOOL BUILDING, ATHENS, ALA.

TRINITY SCHOOL. In 1865, Mary F. Wells organized a school to educate former slaves and their children. Trinity High School in Athens remained in operation for 105 years under the auspices of the American Missionary Association. The school boasted many future community leaders among its graduates, as well as people who would earn fame nationwide, including singer Patti Malone and author C. Eric Lincoln. In 2009, a group formed to preserve the last school building at the site as a museum. (Courtesy of the Trinity Archives.)

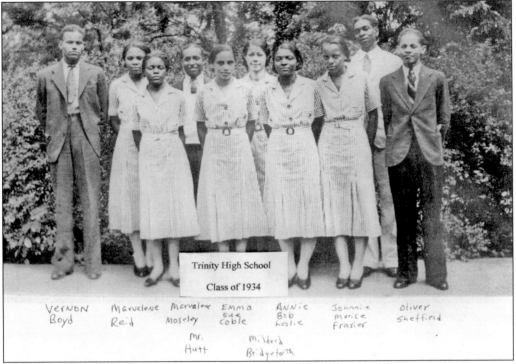

Trinity High School

Class of 1934

Vernon Boyd · Marvalene Reid · Marvalene Moseley · Emma Sue Coble · Annie Bob Leslie · Johnnie Marice Frasier · Oliver Sheffield

Mr. Hutt · Mildred Bridgeforth

TRINITY CLASS OF 1934. In this photograph of the Trinity High School class of 1934 are, from left to right, Vernon Boyd, Marvalene Reid, Marvalene Moseley, a teacher identified as Mr. Hutt, Emma Se Coble, Mildred Bridgeforth, Annie Bob Leslie, Johnnie Marice Frasier, unidentified, and Oliver Sheffield. Celestine Higgins Bridgeforth, who graduated in 1938, said it was a long-standing tradition for senior girls to select fabric and sew matching dresses for graduation in home economics class. (Courtesy of the Trinity Archives.)

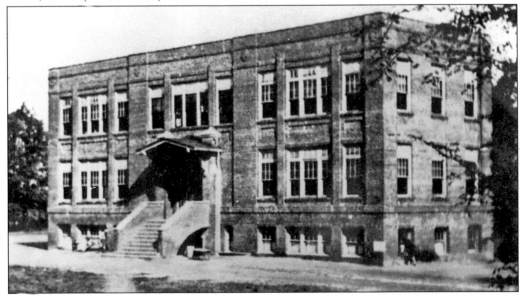

CUMMINGS HALL. This is Trinity High School as it appeared from 1916 until 1930, when a new wing called Cummings Hall was added. (Courtesy of the Trinity Archives.)

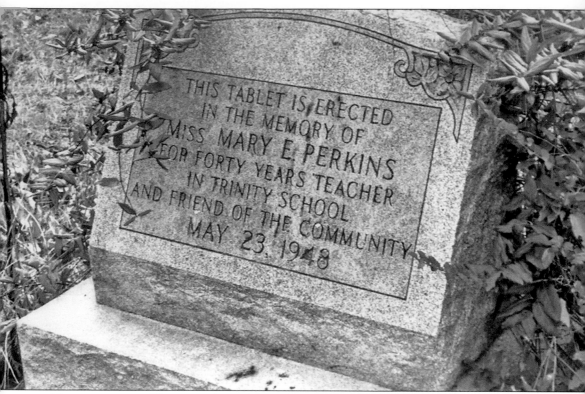

MONUMENT TO A TEACHER. A monument was erected by Trinity High School graduates in memory of a favorite teacher, Mary Emma Perkins, who came to Athens as a young girl to teach. A spinster, she retired after 40 years and lived in a home on Trinity campus for the remainder of her life. (Courtesy of the *News Courier*.)

CALHOUN COMMUNITY COLLEGE. Decatur Trade School was closed during World War II, but in 1946 it reopened using war surplus equipment and added courses to help train war veterans to return to jobs. But learning a trade was noisy, and city residents complained; so in 1947, the school moved to Limestone County to the empty barracks at Pryor Field, now Pryor Regional Airport, which had been used to train World War II pilots. That year, men could take courses in barbering, cabinet making, watch repair, refrigeration, and sheet metal. In 1953, the trade school was ceded to the State of Alabama, becoming John C. Calhoun State Technical Junior College and then, in 1973, John C. Calhoun Community College. (Courtesy of the John. C. Calhoun Community College Archives.)

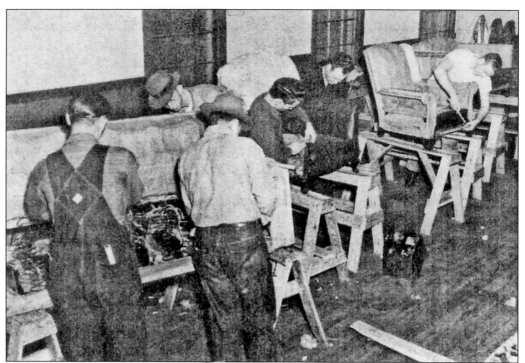

MAKING FURNITURE. In 1949, students at Decatur Trade School, then located at Pryor Field in Limestone County, could learn the trade of furniture making. (Courtesy of the John. C. Calhoun Community College Archives.)

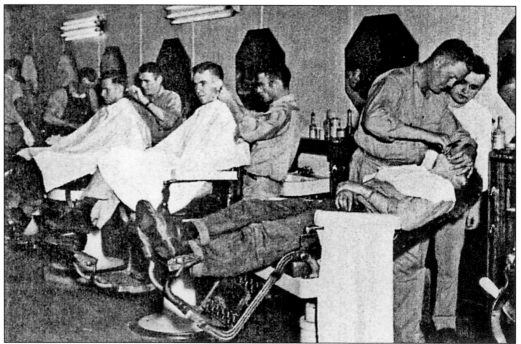

LEARNING TO BARBER. This photograph from a 1949 brochure shows students at Decatur Trade School taking barbering courses. (Courtesy of the John. C. Calhoun Community College Archives.)

Three

PIVOTAL EVENTS

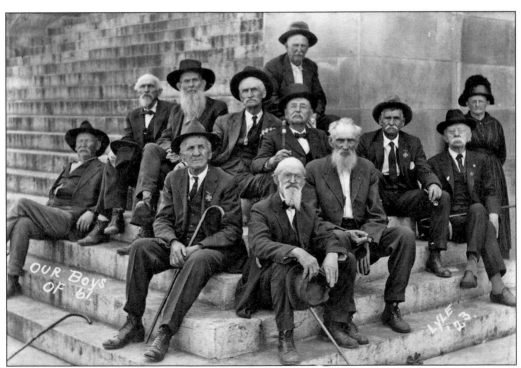

CIVIL WAR. This photograph was taken in 1923 by the now-defunct portrait business Lyle Studios. On it is written "Our Boys of '61," and the group is said to be the surviving Civil War veterans at the time, as well as the wife of one veteran. Pam Waddell, who submitted this photograph, said her ancestor Albert M. McCormack (1837–1926) is the man with the hat and long gray beard. According to Evelyn Berzett, one of her ancestors, James Francis Morgan (August 6, 1845–November 29, 1936), sits on the far right. Behind him is his wife, Frances Daly Morgan (December 12, 1848–July 17, 1924). (Courtesy of Pam Waddell.)

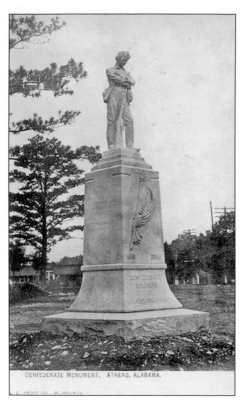

CONFEDERATE MONUMENT, ATHENS, ALABAMA.

CIVIL WAR MONUMENT. After it was commissioned, this monument to local Confederate soldiers was placed in the intersection of Market and Marion Streets on the square in downtown Athens, as shown on this postcard. When townspeople protested the soldier's bowed head and appearance of defeat, a second, more proud-looking statue was ordered. As was the case in many Southern towns, the Civil War left many Athenians bitter. In 1862, the city was sacked by troops under the command of Col. John Basil Turchin. The commander stood by as his troops occupied and burned homes and buildings, plundered the town, and reportedly raped some of its female citizens. Turchin was court marshaled for his actions, but the guilty verdict was voided, and Turchin was promoted to general. The ancestors of those who had been victimized during the sack half a century earlier did not want to give off an air of defeat; therefore, in 1912, this statue was removed from its base and placed in Athens City Cemetery, where its bowed head demonstrates reverence. The new statue was placed on the original base and moved to the courthouse lawn where it stands today. (Courtesy of Athens State University.)

CIVIL WAR MEMORIAL. When it was moved from the downtown square, the statue of the Confederate soldier with his head bowed was placed in Athens City Cemetery. It is now the centerpiece of a circle of Confederate markers placed by Sons of Confederate Veterans and United Daughters of the Confederacy in honor of local men who fought. (Author's collection.)

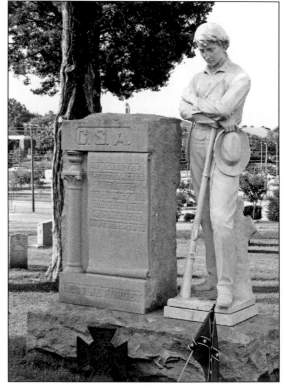

SITE OF BATTLE OF SULPHUR CREEK TRESTLE. Dressed in finery, Edna Horton Hatchett (sixth from left) and friends pause under Sulphur Creek Trestle between Elkmont and Hays Mill during a Sunday afternoon stroll, probably around 1912. Dr. Will Maples is at far left. Next to him are Edna Hatchett's brother Will Horton and his wife, Leona. The trestle was the site of Northern Alabama's bloodiest Civil War battle. The September 1864 Battle of Sulphur Creek Trestle cut a crucial Union supply line. The Confederate victory was led by Gen. Nathan Bedford Forrest. (Courtesy of Anna Hatchett Holland.)

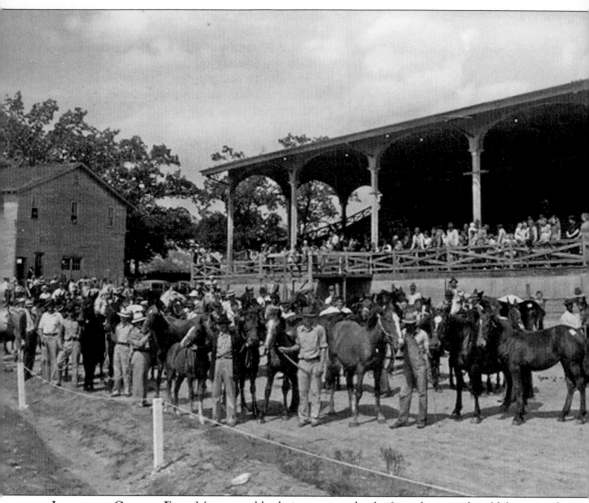

LIMESTONE COUNTY FAIR. Men assemble their mares and colts for judging at the old fairgrounds on Market Street across from the Athens Post Office. The building in the background at left is the floral hall, where competitions in home arts such as sewing, baking, and canning took place. Next to it is the grandstand where fairgoers gathered to watch harness racing. The fair usually arrived in the fall when folks' pockets were filled with cotton-picking money. The lure of the midway included rides like the Ferris wheel and the Tilt-a-Whirl, along with opportunities to test skills by swinging a sledge hammer, pitching coins, tossing rings, shooting at a moving row of plastic ducks, and pitching coins into dishes of carnival glass. Barkers touted side shows where deformed animals and, sometimes, deformed people were on display. (Courtesy of Sara Lipham.)

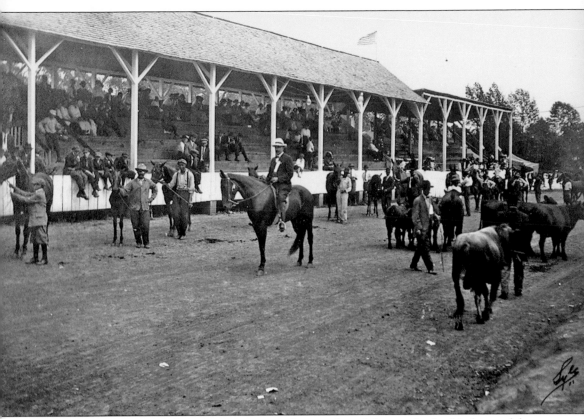

LIVESTOCK SHOW. M. A. Phillips, center, waits in the grandstand during the final judging of the livestock at the Limestone County Fair. When the fair was in town, school would close on Friday, and the entire family would go in the morning and stay until night, riding all the carnival rides and staying for the Friday night fireworks. (Courtesy of Ethel Phillips Wiggins.)

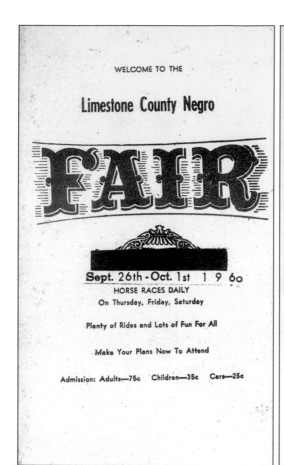

WELCOME TO THE

Limestone County Negro

FAIR

Sept. 26th - Oct. 1st 1 9 60

HORSE RACES DAILY
On Thursday, Friday, Saturday

Plenty of Rides and Lots of Fun For All

Make Your Plans Now To Attend

Admission: Adults—75c Children—35c Cars—25c

1959 MEMBERSHIP ROLL

Charlie Bartlett	Dave Houston
Emory Bridgeforth	Willie Jones
William Bridgeforth	Carrie Mason
Mary E. Caldwell	Clara Mason
Robert Caldwell	Ella B. Mason
Etta Coble	John Watkins
B. L. Crittenton	Frank McLin
Donna H. Crittenton	Odell Smith
Percy Crutcher	James Townsend
Ruth Fletcher	Will Alyce Townsend
Bertha Higgins	Ben Troupe
	Nancy Washington

John Watkins

DIRECTORS

Robert Caldwell Willie Jones
B. L. Crittenton Ella B. Mason
Will Alyce Townsend Ben Troupe
William F. Bridgeforth John Watkins

Odell Smith

OFFICERS

B. L. CRITTENTON President
WM. F. BRIDGEFORTH Vice President
ODELL SMITH Secretary
B. L. CRITTENTON General Manager
JOHN WATKINS Treasurer
DONNA H. CRITTENTON Race Secretary
ELLA MASON Accountant
BEN TROUPE Supt. of Grounds

NEGRO FAIR. "The whites had their fair the last week in September; we'd have ours the first week in October," the late Will Alyce Townsend once said. She saved this Limestone County Negro Fair booklet as a memento of good times. Both fairs were held in the same fairgrounds and followed the same format with harness racing, livestock judging, and competitions in skills such as needlework, baking, and gardening. Townsend said it was permissible for whites to attend the Negro fair, but not vice versa. She said harness racing continued at the Negro fair long after the white fair had discontinued it. (Courtesy of *Etched in Limestone*.)

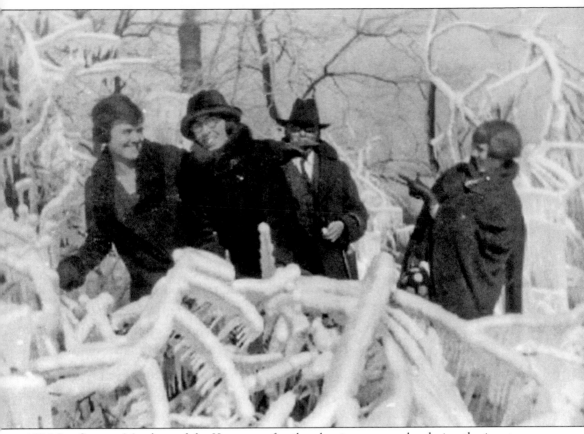

1924 ICE STORM. Members of the Kennemer family take time out to play during the ice storm of 1924. From left to right are sisters Mollie Kennemer and Florence Kennemer and their father, James Kennemer. The person at right is tentatively identified as another sister, Annie Kennemer. (Courtesy of Susan Nelson.)

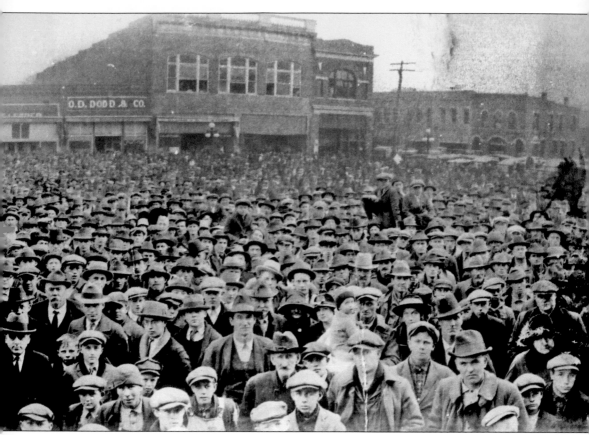

TRADE DAY. From 1922 to 1925, Athens celebrated Trade Day. Residents would go from merchant to merchant making purchases and receiving tickets equal to the amount of money spent. The tickets were then placed in a pot for a drawing of a new car. This photograph was taken on the east side of the courthouse square. The Martin-Richardson-Malone Department Store is the largest store in the center background. (Courtesy of the Limestone County Archives.)

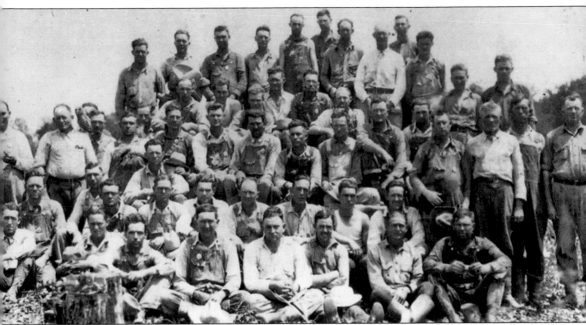

FIRST POWER FROM TVA. Tom Strain (second from left, standing) and Martin Whitt (standing at far right) were foremen of the TVA land-clearing crew pictured here. The round buttons many of the men are wearing were for identification. Each button listed the crew number (this was unit 44) and the individual's identification number. An owl can be seen perched on Strain's shoulder. Strain's son Gene said he believed his dad brought the owl in from the woods down around Decatur and tamed it. The photograph was made around 1934, the year the city of Athens first received its electricity from the Tennessee Valley Authority. Athens was the first city in Alabama to get TVA power. (Courtesy of Marjorie Whitt Walker.)

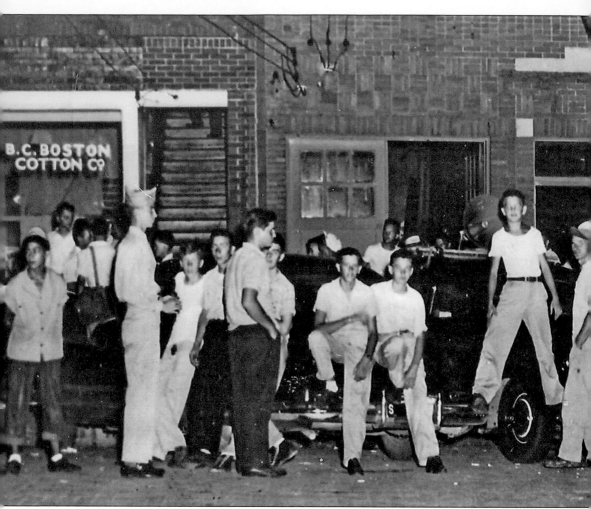

RACE RIOT OF 1946. Tensions between blacks and whites were high following World War II and during the elections of 1946. Racial disturbances occurred that year in Monroe, Georgia; Simpson County, Mississippi; Spokane, Washington; Miami, Florida; Atlanta, Georgia; Philadelphia, Pennsylvania; and Swedesboro, New Jersey. In Athens, violence began at about 1:30 p.m. on August 10, 1946, when brothers Ben and Roy Massey—young white men—got into an altercation outside the Ritz Coffee Shop on Madison Street with L. C. Horton, an African American man. This photograph shows bystanders on the west side of the square following the riot. According to newspaper reports from the time, acting police chief Jess Hargrove and a patrolman took the white men into custody, but Horton was nowhere to be found. White bystanders protested the arrests. Someone said Horton had dashed into the Ritz Theater next door. The crowd called for manager Robert "Spot" Cannon and searched the theater. When Horton was not found, the searchers gathered at the Athens jail, where a mob had formed demanding release of the Massey brothers. Newspaper photographs from the time show the screen doors of city hall ripped and hanging from their hinges as the crowd tried to enter the jail. The Masseys were released in hopes of squelching the mob, but some of the white crowd ran through Athens in a reported attempt to rid it of any black people and harassed, frightened, and sometimes assaulted African American residents in the bus station and in businesses. Nine people were arrested. Some reports say that as many as 100 African American residents were injured, but newspaper accounts state that none required hospital care. (Courtesy of Ewell Smith.)

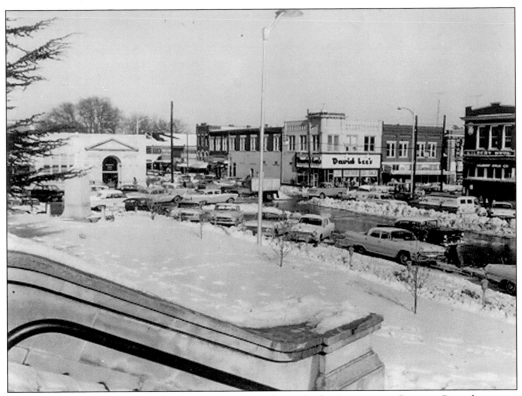

RARE SNOW. Jack Harper took a break from his job inside the Limestone County Courthouse to snap a photograph of the snow-covered east side of the square sometime probably in the early 1960s. At left is either First Alabama Bank or its predecessor, Limestone County Bank, in the building where Limestone Drug is now. David Lee's is visible across from Gilbert Drug Company. Snow accumulation is rare in Northern Alabama. (Courtesy of Cora Harper.)

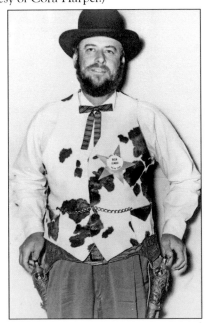

OLD ATHENS WEEK. Alabama Alcoholic Beverage Control Board agent Carlos O. Nelson dons period costume in 1960 during Old Athens Week. Army cannons fired off a volley of blanks on the courthouse square as Sen. John Sparkman helped kick off the celebration. Later in the week, 1,800 students of Athens city schools performed a pageant. An Old South ball was held at the armory. (Courtesy of Larry Nelson.)

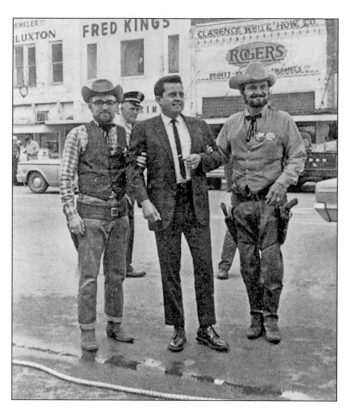

ATHENS SESQUICENTENNIAL. Deputy Kenneth Andrews (left) and sesquicentennial sheriff John Hector French (right) haul Athens Ford dealer Jack Yarber in for a session of kangaroo court during activities celebrating 150 years since Athens was incorporated in 1818. Automobile dealers seemed particularly targeted by sesquicentennial law enforcement officials. A 1965 Chrysler was impounded, and owner David Gordon was jailed without bond. (Courtesy of Donna French Townshend.)

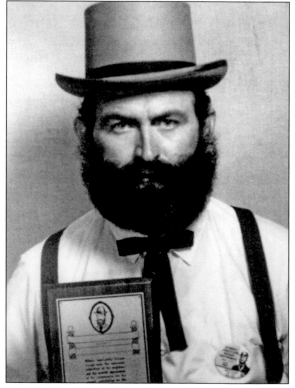

BEST BEARD. Hugo Bates was named "Daddy of the Big Brush" during the Athens sesquicentennial celebration. Other beards of note among the 115 entries were those of J. L. Lomax, reddest; Ray Eldred, whitest; Bill Lewis, blackest; Duane Counter, best trimmed; Ed Jernigan, most unusual; and Frank Looney, skimpiest. (Courtesy of Hugo Bates.)

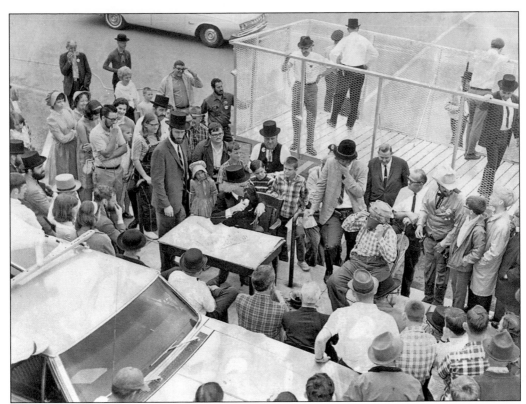

Sesquicentennial Roundup. A crowd gathers at the Limestone County Courthouse Square to watch judge R. L. Hundley (seated at center) preside over the case of Cousin Josh (a character created by radio personality George Rose) during the Athens sesquicentennial. Newspaper accounts report that Cousin Josh made his getaway at some point in the proceedings. The tall man to the left of the judge's bench is prosecuting attorney Jere Trent. Beside Trent, newsman Bob Dunnavant Jr. watches the proceedings. To the left of Cousin Josh is defending attorney Jimmy Woodroof. To the right of Woodroof, in the dark suit, is Athens chief of police A. B. Lightfoot. Sesquicentennial sheriff John Hector French stands farther to the right. In the background, other felons await trial in a makeshift holding pen. (Courtesy of Jere Trent.)

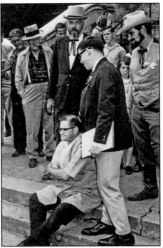

Kangaroo Court. Defendant J. C. Dobbs gets his comeuppance for misdeeds during the Athens sesquicentennial in 1968. Dobbs (seated beside his court-appointed attorney, Jimmy Alexander) was convicted in kangaroo court after it was discovered his "sissy pass," which allowed him not to grow a beard, was a sesquicentennial Belle button. In back, at right, is sesquicentennial sheriff John Hector French. The man at center in the top hat is deputy Austin James. Jere Trent was prosecuting attorney. (Courtesy of Donna French Townshend.)

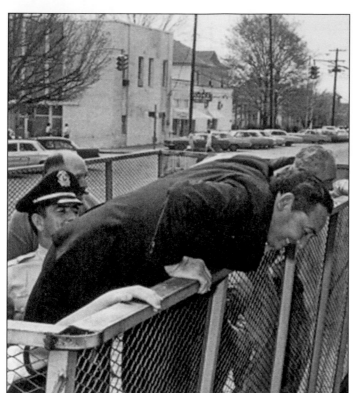

SESQUICENTENNIAL JAILBREAK. David Gordon is caught on camera during an attempted jailbreak prior to kangaroo court at the Athens sesquicentennial in 1968. His crime was that he did not grow a beard and could not produce a permit allowing him to be seen in public without facial hair, which was required during the event. Gordon was aided and abetted by Athens police lieutenant Lewis Leach, at left, who was disarmed and jailed earlier. (Courtesy of Donna French Townshend.)

DUB AT SESQUICENTENNIAL. Dub Greenhaw, owner of Dub's Burgers, a well-known Athens eatery that is still in business, joins the sesquicentennial celebration at the Limestone County Courthouse Square in 1968. (Courtesy of Edna Greenhaw.)

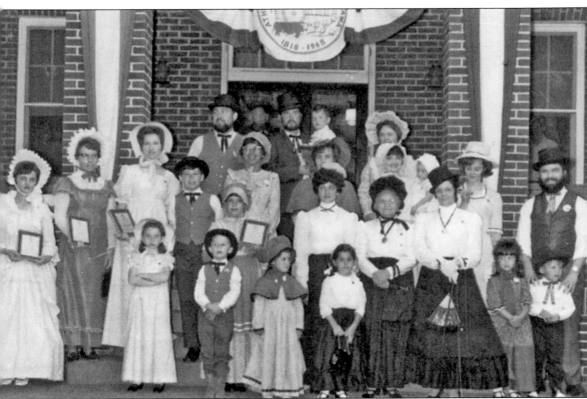

CELEBRATING SESQUICENTENNIAL. Athens sesquicentennial celebrants gather in front of the Ross Hotel on East Washington Street in May 1968. Identified by Don Osborne are the following: Sybil Fudge, second lady from left; Price Wayne Boyd, man in vest and white sleeves at top of photograph; his wife, Calla, just below him and slightly left; next to her is their son Dennis; in front of Calla is her daughter Debra Hemphill; and in front of her in the derby hat is Gary Boyd. The Boyds won an award for best-costumed family during the sesquicentennial activities. At far right is Frank Griffin. To his right are his wife, Faye Mahan, and their two children, Angie Canterino and Brett. In front at far right in the white blouse, black hat, and fan-shaped purse is Merle Osborne. To her right in the black bonnet is Mrs. Harry Nichols, mother of Maurice and Bill Nichols. (Courtesy of Don Osborne.)

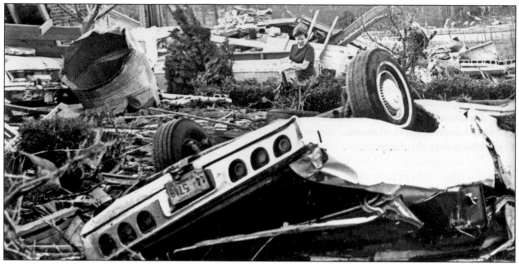

1974 TORNADOES. On April 3, 1974, the Tanner community in Limestone County was in the direct path of two deadly tornadoes that were part of the 148 tornadoes to hit 13 states that day. The East Limestone community also was struck, and several counties surrounding Limestone were in the path of six deadly tornadoes that hit the state that night. Gov. George Wallace declared seven counties disaster areas. (Courtesy of the Limestone County Emergency Management Agency.)

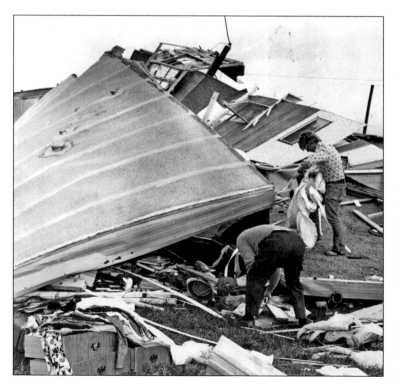

SUPER TORNADO OUTBREAK. The "Super Tornado Outbreak"—so named because of the number of storms and the fact that six tornadoes were given the strongest F5 rating—left Tanner in ruins. (Courtesy of the Limestone County Emergency Management Agency.)

TRAILER PARK STRUCK. Particularly hard hit by the April 3, 1974, tornadoes was Lawson's Trailer Park, shown here. Five people were killed in Limestone County when the first tornado ripped through; 11 were killed in the second storm less than an hour later. Also hit hard in Alabama were Lawrence and Madison Counties. (Courtesy of the Limestone County Emergency Management Agency.)

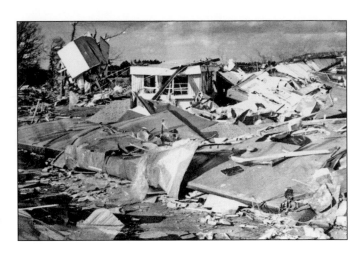

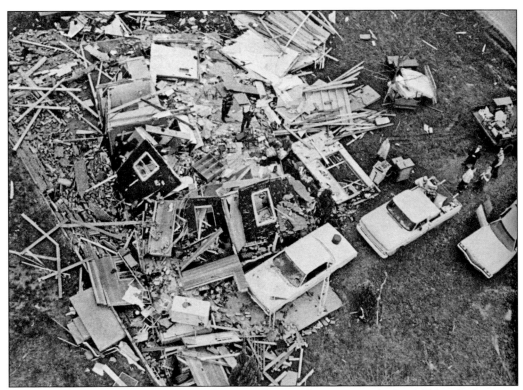

DISASTER AREA. The morning after the tornadoes, authorities search the rubble of a home at Tanner Crossroads. Many of the injured would remain hospitalized in overcrowded facilities in Huntsville, Athens, and Decatur; other families planned funerals for loved ones. Statewide, 86 people were killed in the Super Tornado Outbreak; nationwide, 330 died. (Courtesy of Larry Waldrup, Waldrup Photography.)

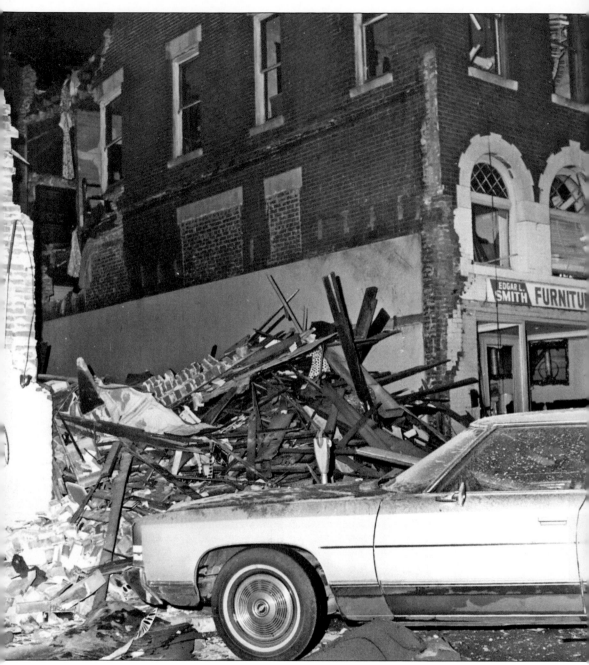

DOWNTOWN GAS EXPLOSION. On Thursday evening, September 5, 1974, an explosion rocked downtown Athens, damaging several businesses on Marion Street beyond repair. The city's gas department manager determined roots from a sycamore tree behind Edgar L. Smith Furniture and Hardware broke the gas line, leading to the explosion. The women's clothing store next door, the LeMar Shop, was completely demolished by the blast. This photograph, published the next day in the *News Courier*, shows the wreckage that had been the LeMar Shop. (Author's collection.)

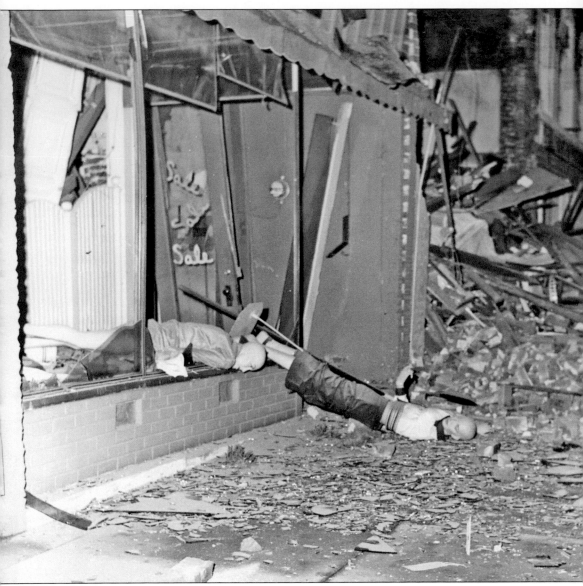

BUSINESS IN RUINS. Mannequins were strewn across the street, probably from the Vogue Shop, following the downtown gas explosion of 1974, causing a few residents to think they were bodies of people killed in the explosion. Because the explosion occurred at about 7 p.m., well after businesses locked up for the day, no one was injured. (Author's collection.)

A Remnant of the Explosion. This piece of glass at Carwile's Barber Shop on Marion Street was left stuck in the wall as a reminder of the gas explosion that demolished several businesses across the street on September 5, 1974. Wayne Carwile, who now owns the shop, said his father, William B. Carwile, wanted to leave this piece, one of about 200 that stuck in the wall. Carwile's Barber Shop celebrated 50 years in business in 2009 and was previously the site of an auto repair garage and a Dr. Pepper bottling plant, Wayne Carwile said. (Courtesy of Kim Rynders.)

Four

Working in Athens and Limestone County

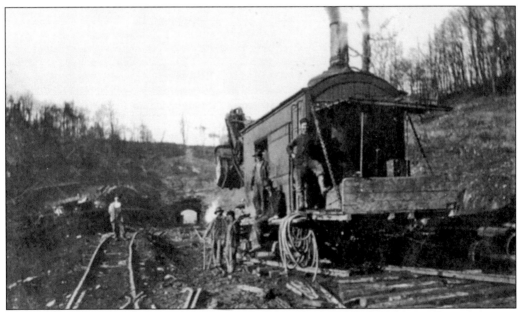

Railroad. This 1914 photograph of construction in the L&N Railroad was taken just across the Alabama line in Tennessee. A tunnel is visible in the background. Lester Wales, standing on the front of the railroad car, was employed to shovel coal to feed the steam-operated engine. Marvin Wales said his father worked for the railroad until construction reached just this side of Nashville. A farmer at heart, Lester Wales reasoned that by the time he was made engineer he would be blind from cinders in the eyes, and so he returned to farming in Limestone County. (Courtesy of Marvin Wales.)

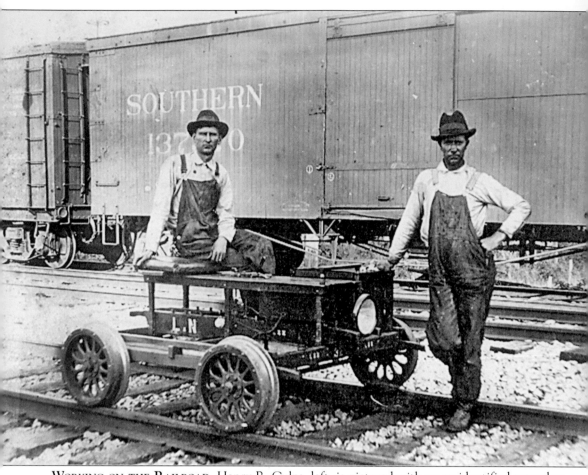

WORKING ON THE RAILROAD. Henry R. Culps, left, is pictured with an unidentified coworker in this photograph taken in Athens during the late 1920s or early 1930s. Culps was a signal maintainer for L&N Railroad. He began working for L&N in Athens in 1914. He later transferred to the Louisville division and lived in Gallatin, Tennessee, where he retired in 1961. (Courtesy of Julia Culps Smith.)

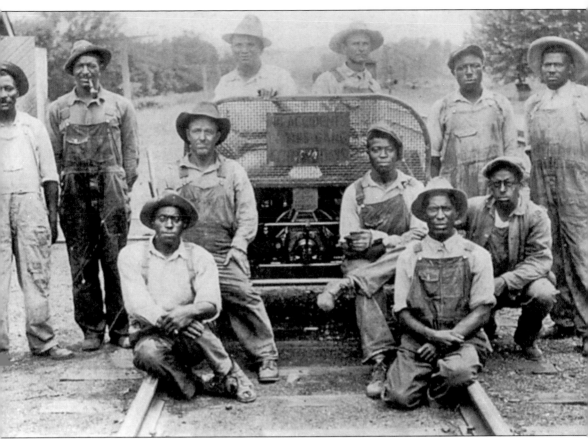

Railroad Crew. L&N track foreman Frank Culps, at right on the motorcar, is pictured with his assistant and crew members in the early 1930s. Culps began working on the railroad in 1915 near his home in the Thach community as a water boy for 50¢ a day. During railroad cutbacks, he moved the family to Tennessee, then returned to Athens in 1947 and was track foreman at Tanner. Culps was close to retirement when the section at Tanner was cut out, and so he took a job sitting in the signal tower at Market Street in Athens and ringing a bell as the train approached. He retired in Athens in 1965. (Courtesy of Julia Culps Smith.)

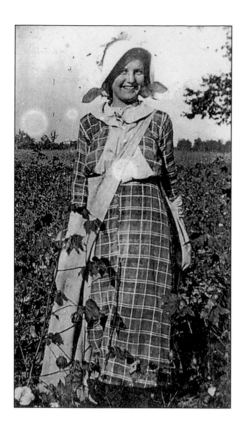

A SACK TO FILL. Lena Covington stands among the rows of cotton stalks, a bonnet protecting her from sunburn and a cotton sack trailing behind her. (Courtesy of Dan Williams.)

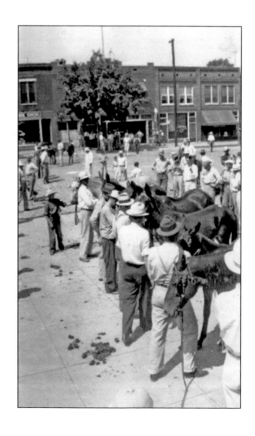

PEDDLING DAY. Men and their mules gather around the west side of the Limestone County Courthouse Square in this photograph probably taken in the 1940s. The fire department and city hall once were located in the building just behind the tree. Farther south along the street, toward Athens First Presbyterian Church, Sara Lipham's husband, Red Corder, ran a grocery store in the 1940s and 1950s. An iron-hitching rail that once encircled the square was taken down to avoid dented fenders. Saturdays on the square were festive in the early part of the century. Farmers came in to peddle farm-fresh vegetables, trade horses, and talk weather and politics. A youngster with 25¢ could buy two hamburgers and a cold drink and see a picture show. (Courtesy of Sara Lipham.)

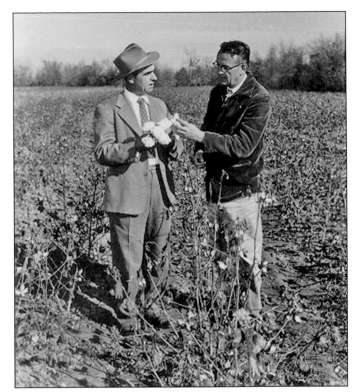

FIELD AGENT. The Agricultural Extension Office played a vital role in farming by dispensing information on the best techniques in planting, pest control, and harvesting. Fred Fergerson (left), a farmer and barber, and Limestone County extension agent F. K. Agee stand in a picked cotton field in this photograph that was probably taken in the 1960s. Agee died in 1973. (Courtesy of Sara Lipham.)

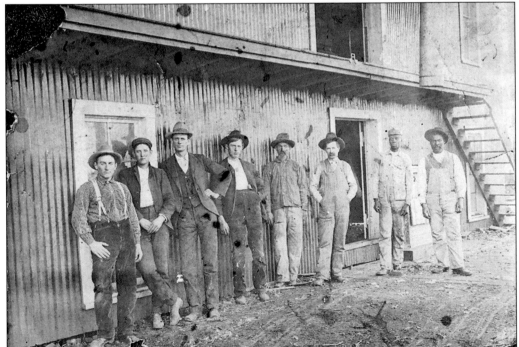

COTTON GINNING. Employees stand in front of Lerman's Gin located in the north Athens community known as Northtown. At left is Luther Wales, who weighed the cotton. (Courtesy of Marvin Wales.)

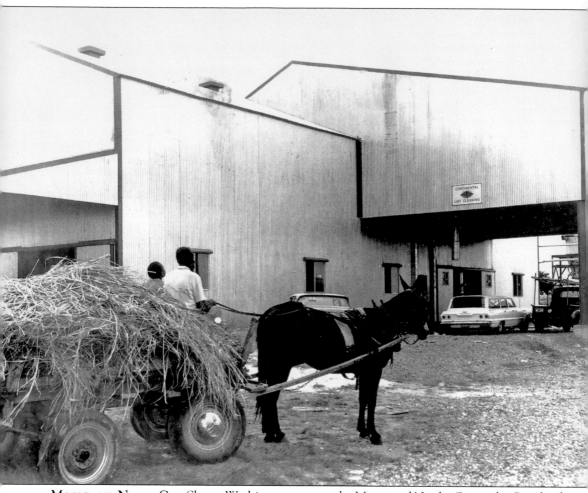

MOORE AND NEWBY GIN. Shorty Washington stops at the Moore and Newby Gin in the Copeland community, which is still in business. (Courtesy of Jean Blair Moore.)

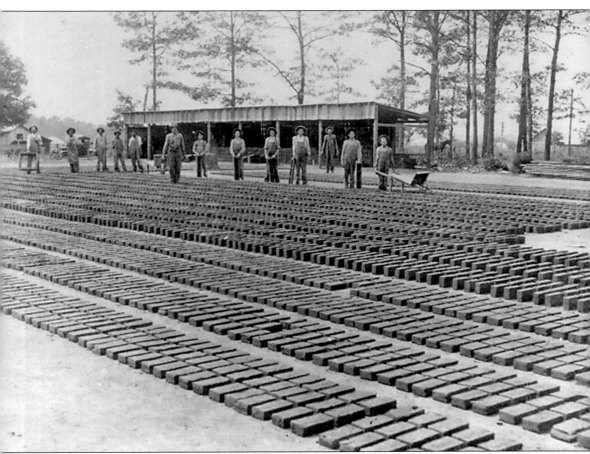

BRICKYARD. Workers are pictured at Athens Brickyard during its heyday. The brickyard was located approximately where Julian Newman School and Athens-Limestone Public Library sit. Faye Axford records in her book, *The Scintillating Seventies,* that an August 30, 1871, article in the *Limestone News* reported that H. H. Higgins and Turrentine had a brickyard opposite Athens City Cemetery and were selling brick at $10 per thousand. Veteran brick mason Gilbert Whitt said Athens Bus Station was built of brick from Athens Brickyard; Faye Axford said that H. H. Higgins, one of its founders, was the distinguished architect who designed Founders Hall, the facade of the Beaty-Mason House, and the 1835 courthouse. It is likely that the brick used in those projects and many others was from Higgins's brickyard. (Courtesy of Milton Looney.)

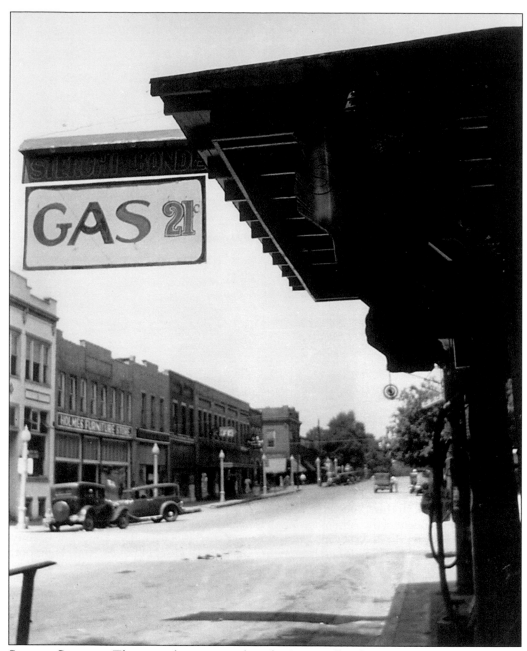

SERVICE STATION. This sign showing gasoline for 21¢ a gallon hung on a service station on Washington Street across from the Opera House, farthest left, which is now Hendricks-Patton. The next stores in the photograph, taken about 1920, are W. E. Estes, the John Deere store, Martin Hardware, Athens Café, Taylor's Barber Shop, unidentified, and McFarland Drug Store. (Courtesy of Richard Martin.)

LAPINGTON STORE.
Robert Lapington
stands on the porch
of the family store
in the O'Neal
community in the
late 1920s. (Courtesy
of Rose Lapington.)

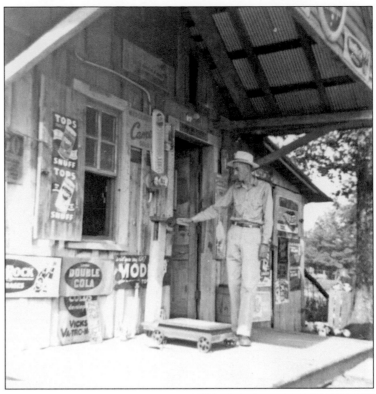

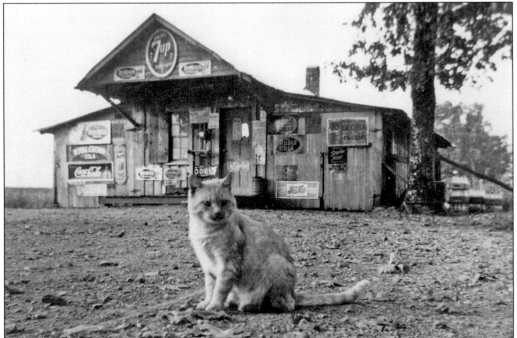

OLD TOM. Old Tom, the Lapington family cat who lived to be 16 years old, sits in front of Lapington's general store in the O'Neal community. The store was built in 1921. (Courtesy of Rose Lapington.)

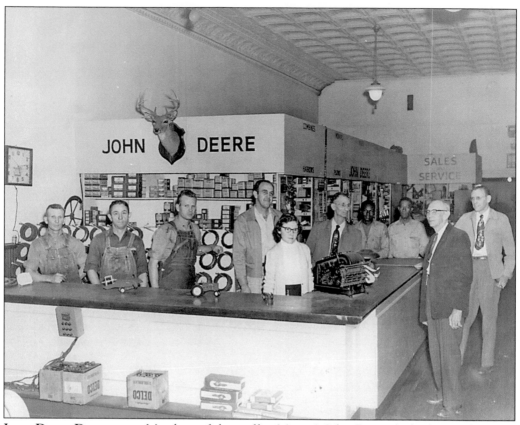

JOHN DEERE DEALERSHIP. Members of the staff at Martin's John Deere dealership in this 1947 photograph are, from left to right, Bill Carter, Elmer Parker, Dick Carter, Lester Birch, Lucille Philpot, Bobby Lee Christopher, Robert Lee, Aubrey Horton, unidentified, and Fred Martin. Richard W. Martin started Martin's Hardware in 1916. In 1933, he added the John Deere dealership next door. (Courtesy of Richard Martin.)

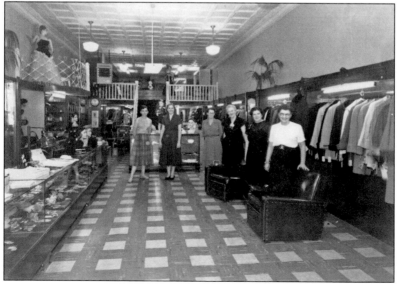

LEMAR SHOP. Leaton Martin (in white blouse at front) opened the LeMar Shop in downtown Athens in the late 1940s. In its time it was one of the finest ladies dress shops in North Alabama. Martin sold the shop just before a gas explosion in 1974 destroyed the building. (Courtesy of Ewell Smith.)

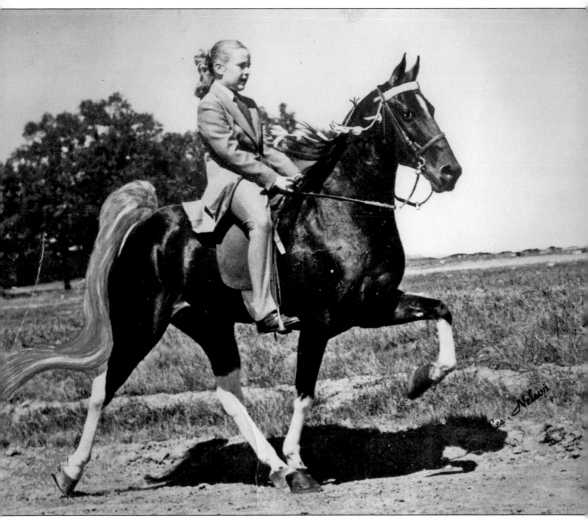

SWEET SUE. Susie Beasley, shown above in 1953, was the namesake for an Athens industry that became the internationally known brand Sweet Sue. The company was founded in 1961 by Susie's father, James E. Beasley Jr., as Sweet Sue Poultry. In 1965, the company began production of a canned chicken product in hopes of capturing a government contract that never materialized. Beasley turned to a local café owner and ex–army cook, Red Bennett, for advice on what to do with the excess chicken. Bennett offered his chicken and dumplings recipe to develop as a canned product, and it became the company's signature creation. The company was renamed Sweet Sue Kitchens, and James' sons Andy and Jimmy later joined their dad in the business. Susie Beasley Day said original packaging for Sweet Sue included a photograph of her riding this horse, but when products began being sold internationally, some buyers thought the canned goods contained horse meat. Packaging was changed to include an image of a girl in a bonnet. The company was eventually sold to Sara Lee. (Courtesy of Susie Beasley Day.)

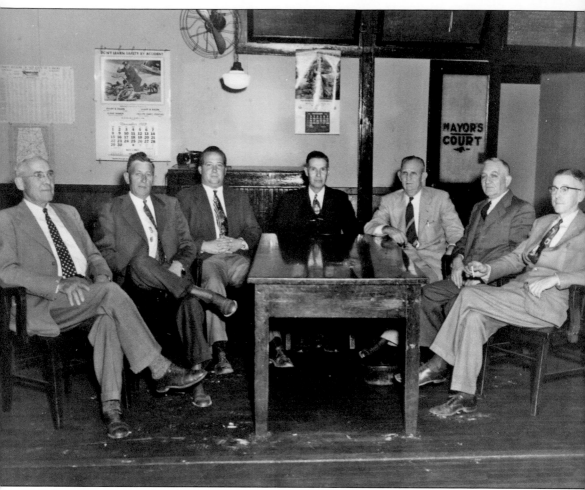

CITY COUNCIL. Before the current city hall was built on Hobbs Street, members of Athens City Council met in an upstairs room on the east side of the downtown square in what is now part of the Rodgers Center at the Presbyterian church. In this photograph, the calendar is turned to November 1953. Shown from left to right are city clerk Maclin Kennemer, ward 4 councilman Walter Gordon, member at large William D. Smith, Mayor Elmer Vinson, ward 3 councilman Ewell Gordon, ward 1 councilman Claude Jones, and ward 2 councilman William B. Crutcher. Later, council members were elected to serve districts rather than wards. (Courtesy of Ewell Smith.)

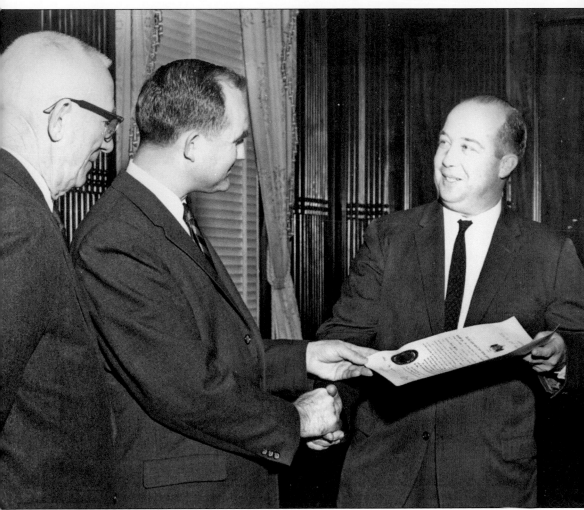

GOVERNOR VISITS. Shown from left to right are local auctioneer Herman Andrews, William D. "Bill" Smith, and Alabama governor John Patterson, who served from 1959 to 1963. Patterson was presenting Smith with a certificate naming him an honorary staff member of the governor's office. Smith was active in Limestone County civic affairs and served four terms on the city council. (Courtesy of Ewell Smith.)

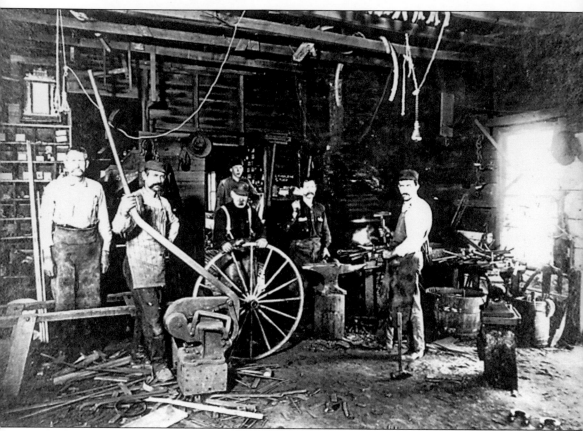

BLACKSMITH. In the unidentified Limestone County shop pictured here, wagon wheels and horseshoes are evidence of the key role the blacksmith once played in transportation. A historical retrospective that appeared in a 1993 issue of the *News Courier* named more than two dozen blacksmiths listed as still in business across Limestone County in the 1850 census. According to that article, Guy Jacobs had come from Kansas in 1900 and opened a blacksmith shop on Jefferson Street south of the courthouse. According to a 1924 advertisement, Jacobs was doing welding and auto repairs, successfully bridging the gap from horse and carriage to horseless carriage. (Courtesy of Milton Looney.)

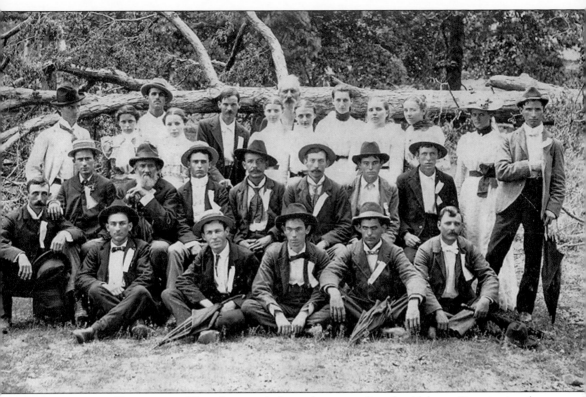

CONSTITUTIONAL CONVENTION. This photograph shows those attending the Alabama Constitutional Convention at Hays Mill on September 17, 1900. From left to right are (first row) Luther Wales, Roy Scoggins, Rip Davis, unidentified, and John Norton; (second row) Ivey Pettus, ? Jones, Lem Hyde, George Whitfield, John Taylor, Will Hollingsworth, Alex Bradford, and Tom Bradshaw; (third row) Earl Pettus, Pearlie King, Cannie King, Mannie Motes, George Brown, Lucy Norton, Hiram McSherry, Floy Pettus, Lena Norvelle, "Boss" Whitt, Laura Norton, unidentified, and Earl Lester. (Courtesy of Marvin Wales.)

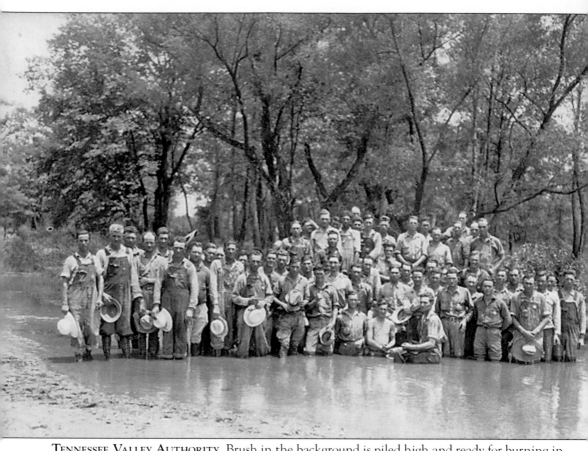

TENNESSEE VALLEY AUTHORITY. Brush in the background is piled high and ready for burning in this 1934–1935 photograph of a Tennessee Valley Authority crew. John Cecil Black is pictured fifth from left in the back row. (Courtesy of Wanda Black Adams.)

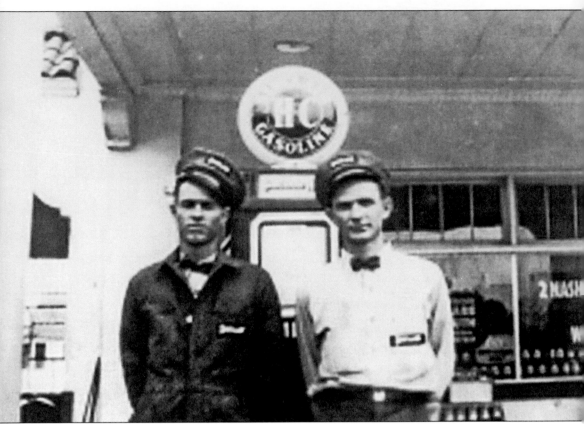

HC Gasoline. W. T. Johnson (left) and his brother Buddy Johnson stand outside HC Gasoline around 1935. The service station, situated in the southeast corner of Washington and Jefferson Streets, was owned by Buddy. W. T., who had just graduated from high school the year before, worked for his older brother. (Courtesy of Nancy Jo Johnson Maples.)

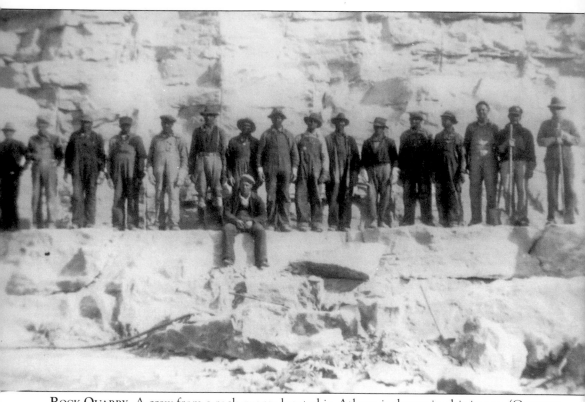

ROCK QUARRY. A crew from a rock quarry located in Athens is shown in this image. (Courtesy of the Limestone County Archives.)

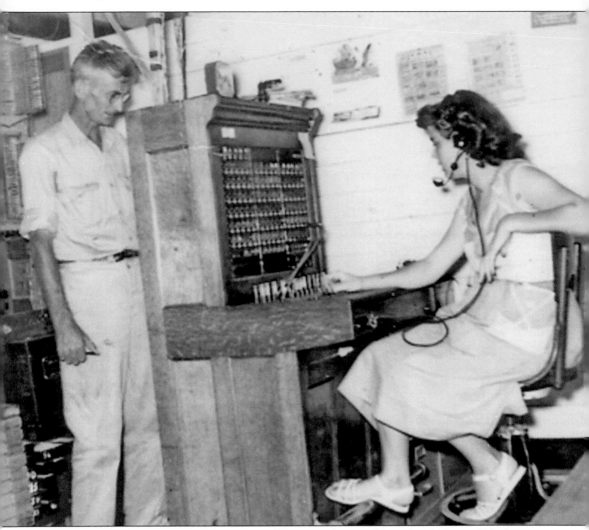

TELEPHONE COMPANY. Marge Merrell McConnell operates the switchboard at Ardmore Telephone Company while her father, Fountain Merrell, supervises. The photograph dates from 1952. Fount Merrell bought the company in 1948 from Haney White, whose father, Tommy White, founded it. Merrell kept the business until late 1958, incorporating it; buying exchanges in Minor Hill, Elkmont, Dellrose, McBurg, and New Market; and going to a dial system. Another of Merrell's daughters, Loretta Ekis, also invested many hours at the switchboard. (Courtesy of Beverly McConnell Browning.)

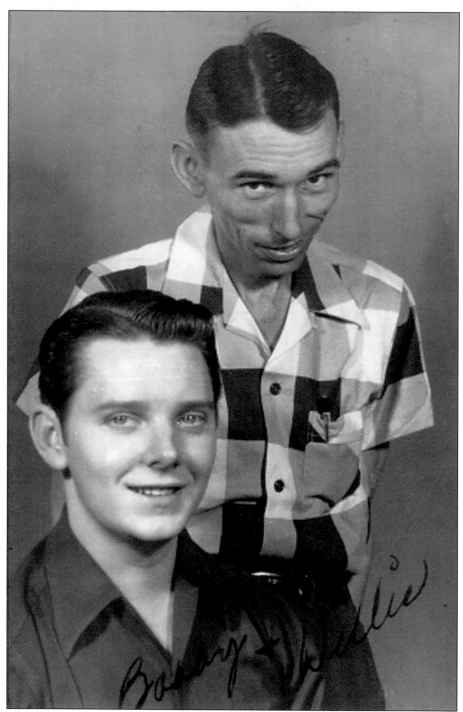

RADIO. This autographed publicity photograph of Bobby Langford and Willis Eady, disc jockeys at WJMW radio station in Athens, was taken in 1952. Station owner Bob Dunnavant said Langford started working at WJMW when he was still in high school and remained there many years. Eady had a remote broadcast out of Moulton, which had no radio station at the time. (Courtesy of Edith Cantrell.)

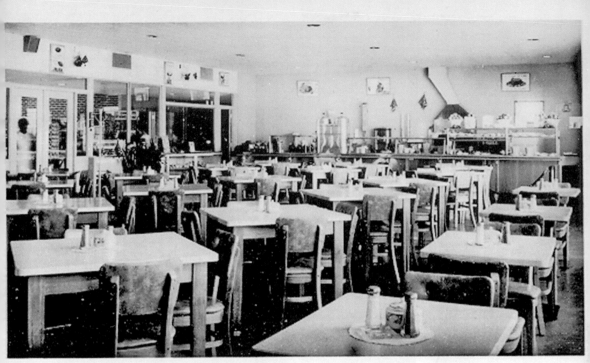

REBEL CAFETERIA – GREYHOUND BUS TERMINAL – ATHENS, ALA.

REBEL CAFETERIA. A postcard from the late 1950s pictures the interior of the Rebel Cafeteria at the Greyhound Bus Terminal in Athens. Proprietor Wilson White worked at Athens Bus Station prior to purchasing it in 1937. In 1955, he built the new bus station and opened Rebel Cafeteria. Though the ticket office closed in 1987, Rebel Cafeteria continued in operation well into the 1990s. (Courtesy of Susan White Lindsay.)

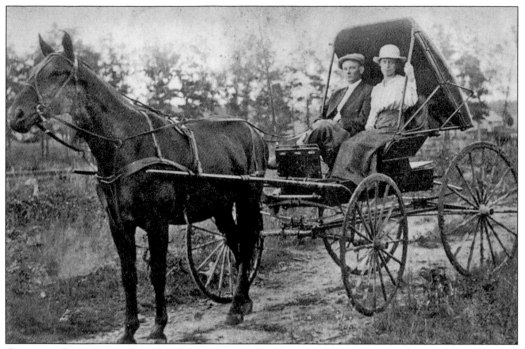

CARRIAGE RIDE. James David and Alice Mitchell Elliott set out for a visit in their buggy. (Courtesy of Nancy Jo Johnson Maples.)

PORTRAIT SITTING. Frank Looney dons a straw hat for this *c.* 1908 portrait of himself and his little brother Aubrey at the family home north of U.S. 72 at French's Mill. Because most families did not own cameras early in the 20th century, photographers went door-to-door in rural areas offering to make family portraits. (Courtesy of Milton Looney.)

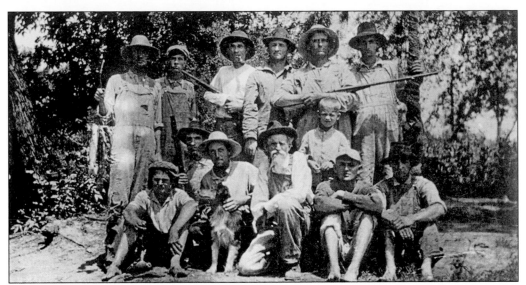

HUNTING AND FISHING. This group of sportsmen pictured around 1910 somewhere along the Tennessee River includes James Madison "Matt" Fielding, John Robert "Butch" Fielding, John Benton Fielding, William Matthew "Willie" Fielding, and Henry H. Fielding. (Courtesy of John R. Fielding Jr.)

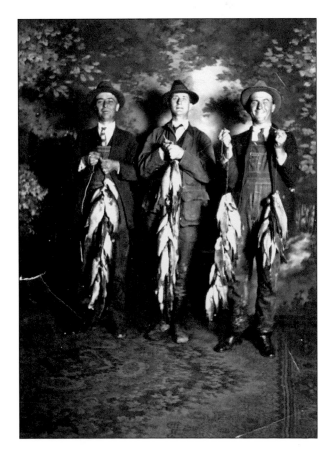

FISHING. Ewell Smith (left), T. D. Copeland (center), and Hobart Clem display their fishing prowess for a professional portrait taken in the late 1920s or very early 1930s. Smith was grandfather of the man who submitted this photograph. (Courtesy of Ewell Smith.)

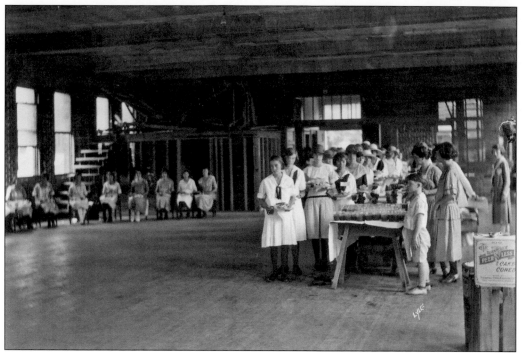

Luncheon. The Athens Commercial Club holds a luncheon for girls in the Limestone County Club in 1923. (Courtesy of the Cooperative Extension System Records, Special Collections and Archives, Auburn University.)

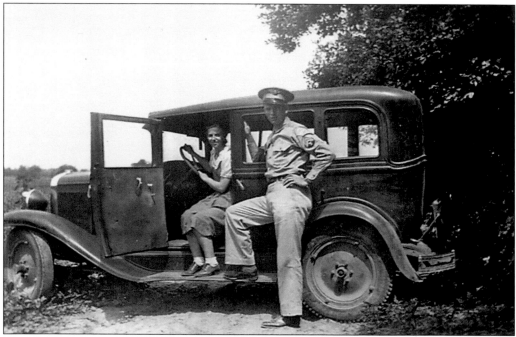

Driving. Sarah Evans gets ready to take brother Richard for a spin in her first car. Richard Evans said he thought the car was a 1931 Chevrolet. His sister was an accomplished driver, accustomed to helping her brothers on the farm by driving trucks and tractors. (Courtesy of Richard Evans.)

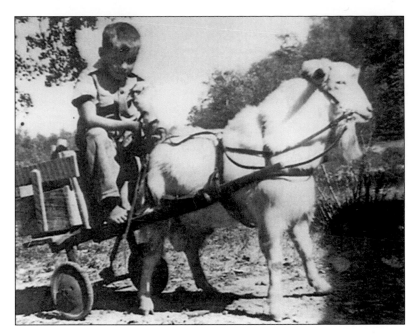

GOAT CART RIDE. Seven-year-old Bill Stinnett goes for a ride in a goat cart powered by his friend Trigger. The photograph was taken in 1942 in Stinnett Hollow in northwest Limestone County. (Courtesy of Bill Stinnett.)

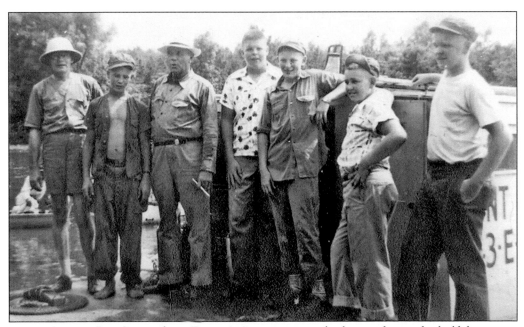

SCOUT CRUISE. Boy Scouts from Troop 240 prepare to embark on a five-and-a-half-day cruise aboard the *Aunt Mary*, a boat they built under the supervision of Bill Chambers. The photograph was taken July 8, 1951. Pictured from left to right are Dr. Richard Tyler Woods, Bill Estes, Bill Chambers, Bobby Swearengen, Johnny Harlow, Jimmy Christopher, and David Martin. Woods and Chambers were the troop leaders. Troop 240 is chartered to First United Methodist Church and holds the record in Limestone County for the troop with the longest continuous charter. (Courtesy of David Martin.)

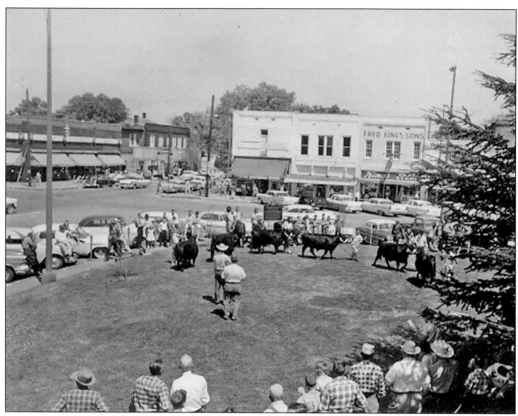

4-H Show. Young 4-H members parade their calves past C. T. "Doc" Bailey, secretary and treasurer of Limestone County Soil Conservation Division, and John Orr (both at center). They were judges in the 4-H Calf Show in downtown Athens. The photograph, taken by Jack Harper, is dated April 20, 1959. (Courtesy of Cora Harper.)

Winning Calf. The winning calf at the 1959 4-H calf show was raised on the farm managed by Hoyt Williamson, chairman of the Limestone County Soil Conservation Division. It was shown by a woman identified as Miss Lollar. (Courtesy of Cora Harper.)

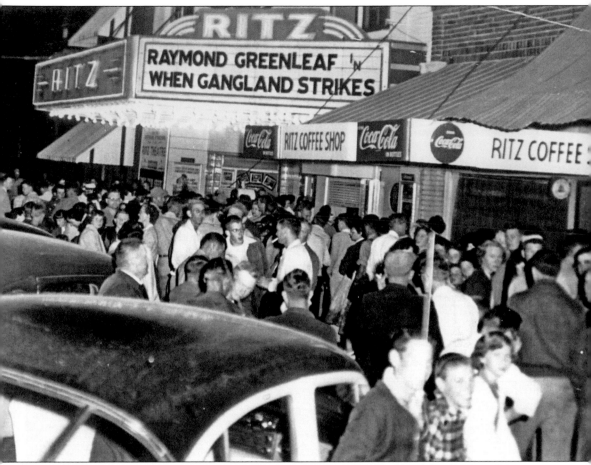

RITZ THEATER. The Ritz Theater had its grand opening on Monday, April 30, 1928, on Marion Street in downtown Athens. The theater, owned by the Muscle Shoals Theatres, Inc., was on the site of the First United Methodist Church that was erected in 1836 with the walls and roof of the old building retained. The original facade was covered. The theater originally had 462 opera chairs with padded seats, with an additional 150 veneered seats in the balcony, 66 of which were reserved for "colored persons" reached by a stairway on the south side of the building. The Ritz could be used for movies as well as plays and vaudeville. The theater closed in 1963 and was purchased around 1970 to be converted to the Gilbert family's furniture store. In 1990, it became the home of its current resident, North Marion Street Church of Christ. (Courtesy of Dwight Gooch.)

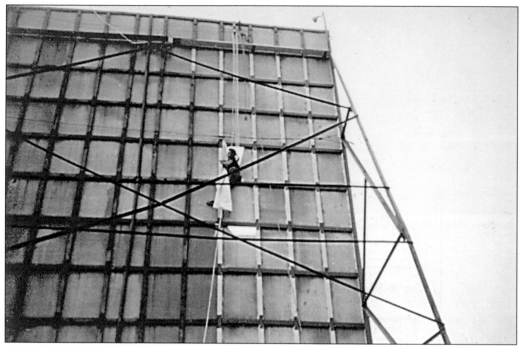

DRIVE-IN SCREEN. Elmo Faulkner replaces a section of the screen at Hatfield Drive-In that was damaged after winds hurled an object through it. The photograph was taken around 1953. (Courtesy Travis Raney.)

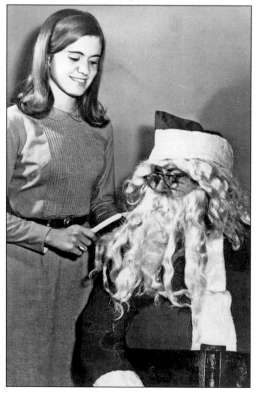

VISIT WITH SANTA. Miss Merry Christmas Jerri Anne Aycock brushes Santa's beard just prior to the Christmas parade. It was a long-standing Athens tradition that ABC agent Carlos Nelson portrayed St. Nick at the parade and other Yuletide festivities. (Courtesy of Carla Nelson.)

PAGEANT. Athens fire chief "Mutt" Bumpus greets the 1967 Fire Prevention Queen, Jackie Cannon, and her court, Vicki Corder (third from left) and Linda Cain (right). (Courtesy of Sara Lipham.)

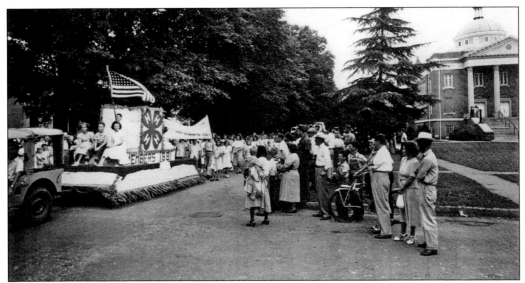

PARADE. The 4-H float proceeds south on Jefferson Street during a parade. First United Methodist Church can be seen at right. (Courtesy of the Limestone County Historical Society.)

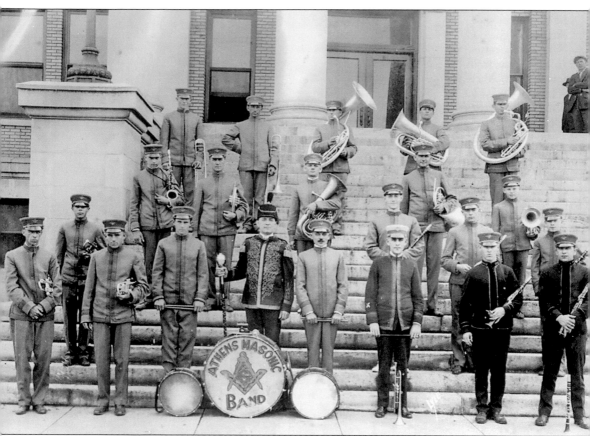

MASONIC BAND. Reba Fry gave this photograph of the Masonic Band from Athens Lodge 16 to Binford Turner a decade after Ronnie Springer, her son-in-law, found it in his attic during remodeling. Athens mayor Dan Williams identified two of the members as his uncles. Second and third from left in the fourth row are James Mack Williams, born in 1902, and Claude Lee Williams, born in 1904. They were the two oldest sons of William Anderson Williams, who was a member of the Limestone County Board of Revenue, District 3, around 1916 to 1928. The photograph probably was made shortly after the completion of the present Limestone County Courthouse in 1919. (Courtesy of *Etched in Limestone*.)

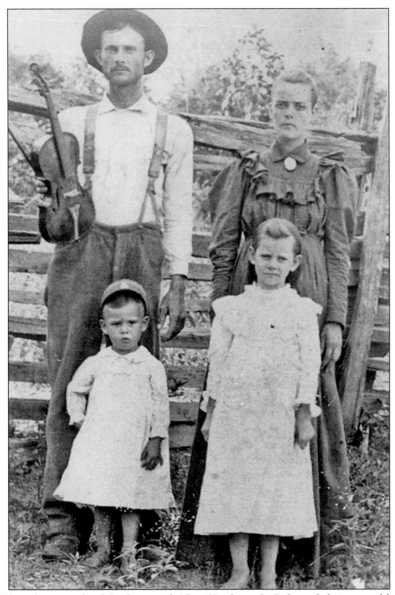

FIDDLING. This photograph of Andrew and Alice Kimbrough Cole and their two oldest children, Lee Cole (later Baker) and William Bryan Cole, was taken when the family lived in Tennessee. Estelle Cole Carwile, the ninth of their 10 children, was seven years old when the family moved to Limestone County. The fiddle Andrew Cole holds belonged to Uncle Bob Cole, who gave it to his nephew after observing Andrew make himself a fiddle out of an axle-grease box, gathering hair from his horse's tail to string the bow. Andrew continued to play the fiddle throughout his adulthood and formed a family band with son James on the violin, son Buford on the guitar, and daughter Estelle on the mandolin. The Cole Band competed at fiddlers conventions held at high schools throughout Limestone County. Estelle Carwile said the first contest she remembered playing in was a fiddling contest in 1927 at the State Secondary Agricultural School. The musical tradition continues through Estelle's grandchildren. John Carwile was the founder of the gospel quartet Clear Title. Daniel Carwile was champion fiddler at the Tennessee Valley Old Time Fiddlers Convention at age 14 and has won the title many times since. (Courtesy of Estelle Cole Carwile.)

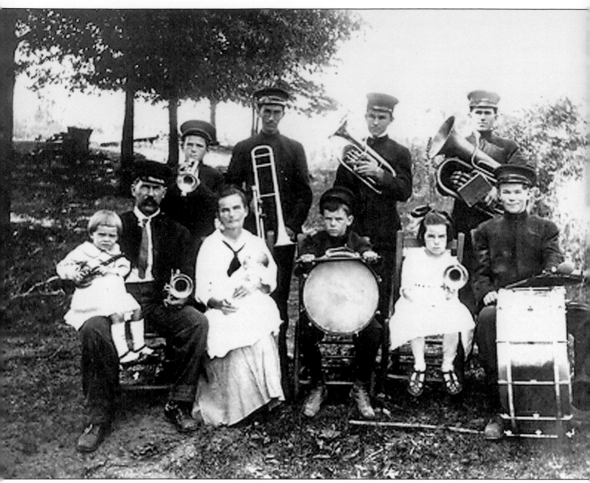

FAMILY BAND. W.A. Williams dreaded the prospect of having his happy family fragmented by war, and so he volunteered to entertain American troops with a brass band composed of him and six of his sons. Though World War I ended before the band ever was called into action, the family band remained in existence, entertaining at family functions. After the death of W. A. Williams in 1928, the band played on the first Sunday of August each year for the 300–400 guests who came to pay their respects to W. A.'s wife, Lota Rogers Williams, in recognition of her August 4th birthday. Pictured from left to right are (first row) Kathryn, piccolo; W. A. Williams, coronet; Lota Williams holding George; Jake, snare drum; Effie, coronet; and Clay, bass drum; (second row) Hasse, coronet; Mac, trombone; Bill, alto horn; and Lee, bass horn. (Courtesy of Dan Williams.)

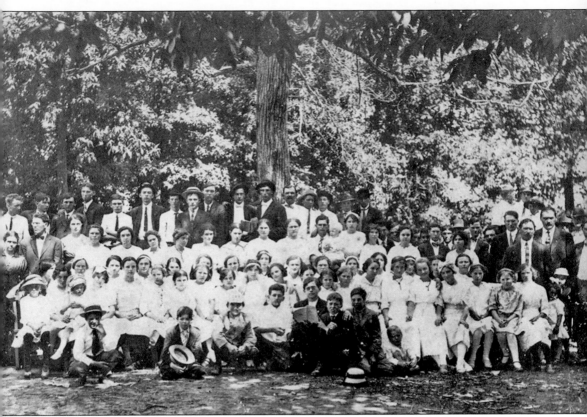

SINGING SCHOOL. This photograph is of a singing school at Mt. Carmel Church of Christ near Clements High School. The young man in front holding the songbook is Lee Williams, Georgia Covington Williams's brother-in-law. The Williams family's musical heritage is an extensive one. Her father-in-law, W. A. Williams, owned a share of Athens Music Publishing Company. W. A.'s sister Mollie was the mother of Alton and Rabon Delmore, the Delmore Brothers, listed in Nashville's Country Music Hall of Fame. Georgia grew up in West Limestone and attended Salem Methodist Church, where there were one or two singing schools each summer led by Vaughn's Music Company of Lawrenceburg, Tennessee; or Stamps Baxter of Texas; or Miller Griggs, who taught locally. Instructors taught shape notes, creating lines and spaces on the chalkboard, drawing in the notes and then drilling the students. (Courtesy of Dan Williams.)

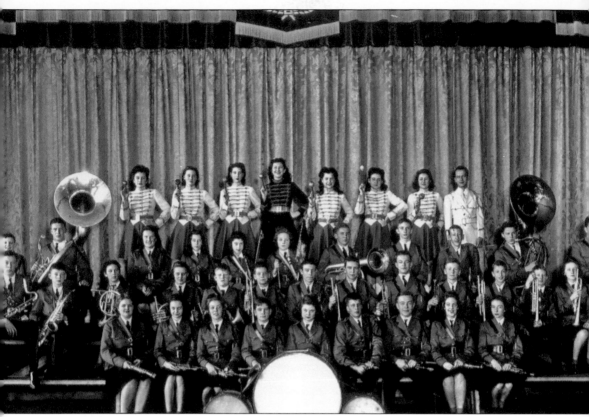

MARCHING BAND. Members of the 1942 Athens High School marching band are, from left to right, (first row) Mary Agnes Isom, Juell Whitt, Mary Carolyn Legg, Charles Thomas, Mildred Rudolph, John Richardson, Glenn Ragan, Martha Frances Dais, and Mildred Ann White; (second row) Henri Howard, Buddy Markowitz, Mot Gordon, Mary Kathelene Jones, D. O. Looney, Billy Caughren, Frank Simmons, John David Chandler, Bobby Nichols, Billy McClellan, David "Brer" Yarbrough, Sonny Andrews, and Dorothy Sellers; (third row) Doug Gordon, James R. "Doc" Thompson, Anna Jean Whitt, Dorothy Shelton, Margaret Jaffe, Lutie Easter, Ed House, Clay Smith, Carl "Speedy" Martin Jr., R. B. Nichols, and Doug Strain; (fourth row) Joyce Holland, Mabel Barker, Mary Agnes Creel, Josephine Keith, Pauline Smith, Bernice Belew, Ethel Southard, and band director Charles Keene. (Courtesy of Anna Whitt Lee.)

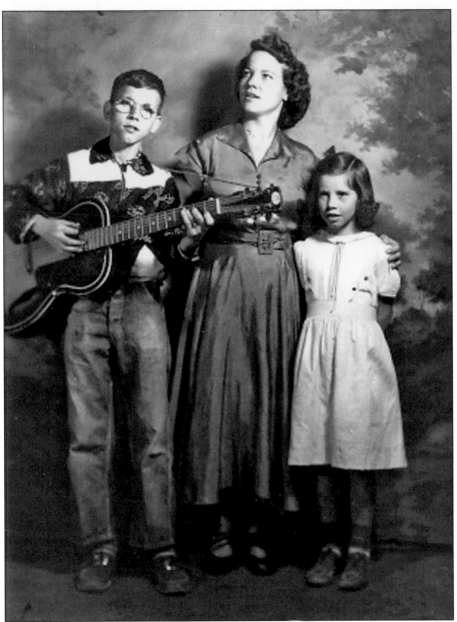

BLAND FAMILY. Edith Bland Cantrell (center) is pictured with brother Floyd Bland and sister Jackie Bland in a 1952 portrait done by Lyle Studio in Athens. The portrait was part of the prize they won after performing as the Bland Kids at a fiddlers contest at West Limestone High School. They also won a smoke stand, though no one in the family smoked; $5 in gasoline, though they had no car and took cash instead; and two bags of groceries from Sneed's in Salem. Edith—who described herself as a Nashville wannabe—often showed up with her siblings at the Limestone County Courthouse Square on Saturday and sang hymns to draw a crowd for preachers who delivered their sermons to passersby. Edith said she sang onstage with Rabon Delmore at Bob Dunnavant's music show in the Plaza Theatre on the south side of the square. The Blands sang at WJMW in Athens, at WBHP and WFUN in Huntsville, and at radio stations in Birmingham and Nashville. (Courtesy of Edith Bland Cantrell.)

FAMILY GROUP. When the Athens Quartet's high tenor was hospitalized for an appendectomy, other quartet members called on Jake Williams, a man they knew from attending Sunday all-day singings around Limestone County, to fill in. Williams continued to sing with the quartet until it disbanded in the 1950s. Accompanied on the piano by Georgia Covington, who became Jake Williams's wife, the quartet sang regularly on WJMW radio station. Pictured from left to right are Jake Williams, high tenor; Floyd Blair, countertenor; Georgia Williams, pianist; Will Bee, tenor; and Sam Mitchell, bass. (Courtesy of Dan Williams.)

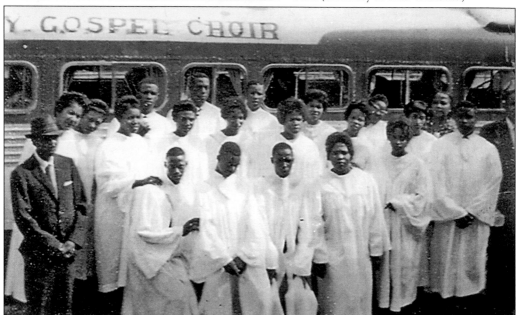

GOSPEL CHOIR. The Athens Community Gospel Choir was organized in 1956 by Roosevelt King, Jesse James Horton, Mason's Funeral Home manager Odell Smith, and the Reverend Paul Smith, pastor of Trinity Congregational Church. Robert Caldwell was the first pianist; Will Alyce Townsend later became pianist. For two decades, the choir sang in churches all over the Tennessee Valley and traveled in summer to places like Rockford, Bloomington, and Chicago, Illinois; Beloit, Wisconsin; Cincinnati, Columbus, and Cleveland in Ohio; Fort Wayne, Indiana; and Louisville, Kentucky. Pictured in front of their tour bus are choir members Will Alyce Townsend, Morris Malone, Estella King Matthews, Irene King Harris, Peggy Fletcher Gordon, Jessie J. Horton, Travis Williams, Horton Matthews, Mary D. Crutcher, Betty Crutcher Brown, Georgia Jordon, Arthur Jordon, Edna L. Fletcher, Martha L. Fletcher Pryor, Paul Holt, Ella Fletcher Gray, Mary E. V. Jackson, Earl King, Price King, Luetta King, Ada Malone, Louise Malone, Charlotte Lucas, Robert Caldwell, Ethelean Jordon Swopes, Elizabeth Mosley, Sylvia Elliott Sloss, James Elliott, Christine Elliott, Charles Banes, Ann Hicks, Wallace Hicks, John Robert Holt, Barbara Rayborn, and Eliza Jackson. The man at left dressed in a suit is Mason Townsend, who went on the tour as an usher. At right is the bus driver, James Jackson. (Courtesy of *Etched in Limestone*.)

124

CONCERT ON THE SQUARE. Dexter and the Derbies entertained at the courthouse square during the town's sesquicentennial. Band members pictured are Dexter Greenhaw, guitarist; Larry Roberson and Leo Cunningham, harmonica; and Karen Sheron, vocalist and pianist. Others who played with the band include Ronnie Romine, Dennis Brooks, Denny Ausley and Mark Gamble. (Courtesy of Edna Greenhaw.)

SCHOOL PLAY. Unidentified Athens Elementary School students take a curtain call in this 1930 photograph of a class play. (Courtesy of the Limestone County Archives.)

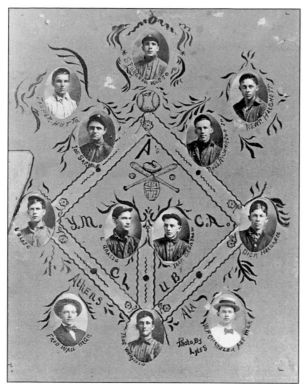

BASEBALL. Baseball was an important facet of entertainment in the first half of the 20th century. Every community had its own team, and entire families turned out on Saturdays to watch them play. In this portrait of a YMCA club in Athens, team members are (outer edge, clockwise from top) Spurgeon Hutto, Newt Hatchett, Dick Hatchett, assistant manager W. P. Chandler, Thomas Whitfield, manager Fred Wall, U. Glaze, and Jasper Hutto; (inside, clockwise from top right) Ross Richardson Jr., Jack Crenshaw, L. Grasse, and Joe Sarver. (Courtesy of Milton Looney.)

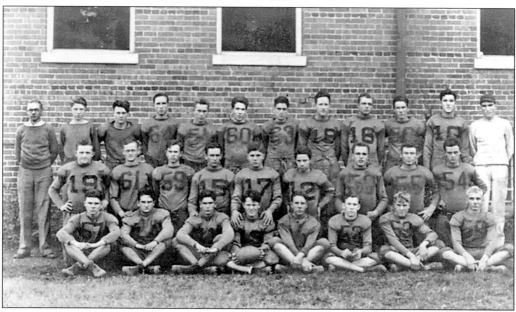

FOOTBALL. Members of the 1933–1934 Aggies football squad at the State Secondary Agricultural School of Athens are identified on the back of this photograph as (first row) E. Norton, W. Terry, W. Gates, D. Grisham, H. McGrew, ? Carter, unidentified, and N. Flanagan; (second row) R. Corder, C. Christopher, T. Johnson, N. Stinnett, B. Stinnett, H. Johnson, T. Turner, R. Gates, and R. Jones; (third row) R. Byrum, M. Tidwell, N. Leopard, L. Alfrey, D. Barker, M. Henderson, R. Jackson, P. Clem, E. Daniel, M. Holland, C. Vines, and ? Vines. (Courtesy of Nancy Jo Johnson Maples.)

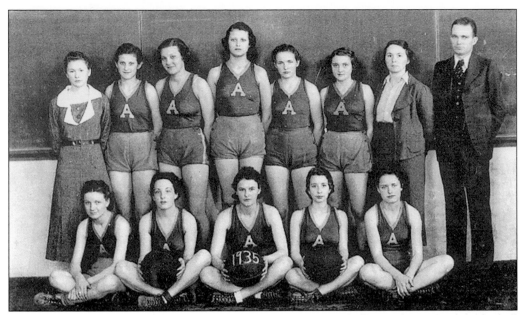

BASKETBALL. Coach O. N. Williams autographed team captain Isabelle Smith's 1935 girls basketball team photograph with the note, "I'm happy that you led your crowd to a victory over Athens High." State Secondary Agricultural School's win over Athens High School was a prized victory. Pictured from left to right are (first row) Frances Christopher, Grace Terry, Isabelle Smith, Lois Vasser, and Martha Lambert; (second row) Mildred Smith, Paulina Thomas, Ida Leopard, Irene Landers, Mary Audra Lambert, Ruth Barker, Valeria Jones, and coach O. N. Williams. On the back of a team photograph from 1932, Shannon had recorded the team's 10-2 win-loss against teams from Falkville, Cullman, Tanner, Elkmont, Ardmore, Austinville, and Piney Chapel. Shannon said girls basketball was discontinued the year after her graduation in 1935. (Courtesy of Isabelle Smith Shannon.)

CHEERLEADING. Pictured during the 1951 Athens High School football season are (front and center) head cheerleader Bobbie Deemer and squad members, from left to right, Danylu McGuire, Martha Lewis, India Hurn, Martha Ann Meadows, Shirley Wellden, Annie Bryan, and Mary Ann Thomas. (Courtesy of Buddy Evans.)

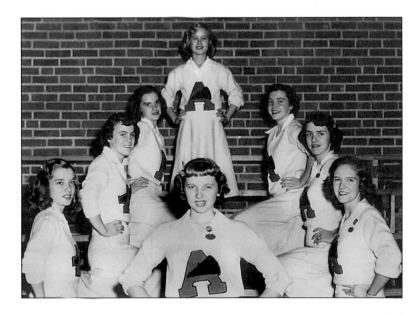

DISCOVER THOUSANDS OF LOCAL HISTORY BOOKS FEATURING MILLIONS OF VINTAGE IMAGES

Arcadia Publishing, the leading local history publisher in the United States, is committed to making history accessible and meaningful through publishing books that celebrate and preserve the heritage of America's people and places.

Find more books like this at
www.arcadiapublishing.com

Search for your hometown history, your old stomping grounds, and even your favorite sports team.